IMAGES
of America

CAPE COD
NATIONAL SEASHORE
THE FIRST 50 YEARS

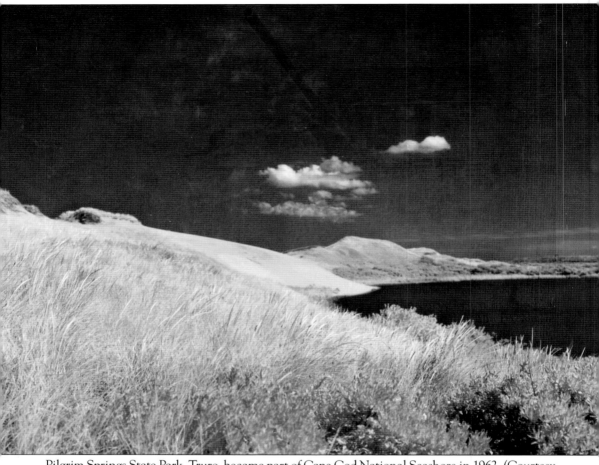

Pilgrim Springs State Park, Truro, became part of Cape Cod National Seashore in 1962. (Courtesy of Cape Cod National Seashore.)

ON THE COVER: Coast Guard Beach, photographed between 1963 and 1969, is one of Cape Cod National Seashore's most popular beaches. (Courtesy of Cape Cod National Seashore.)

IMAGES
of America

CAPE COD
NATIONAL SEASHORE
THE FIRST 50 YEARS

Daniel Lombardo

ARCADIA
PUBLISHING

Published by Arcadia Publishing
Charleston SC, Chicago IL, Portsmouth NH, San Francisco CA

Printed in the United States of America

Library of Congress Control Number: 2009939183

For all general information contact Arcadia Publishing at:
Telephone 843-853-2070
Fax 843-853-0044
E-mail sales@arcadiapublishing.com
For customer service and orders:
Toll-Free 1-888-313-2665

Visit us on the Internet at www.arcadiapublishing.com

Dedicated to Dale Peiffer, who introduced me to Cape Cod
44 years ago, and Karen Banta, who shares the Cape with me today.

CONTENTS

ACKNOWLEDGMENTS

Thanks to the incomparable Hope Morrill, Bill Burke, George Price Jr., Jack Farley, Sue Haley, Jenna Sammartino, David Spang, Bob Grant, John Portnoy, Elizabeth Nelson, Mike Whately, and Karen Banta. Thanks to the friends and family I neglected while writing this, especially the little ones, Simonne Lombardo and Viviana Rodriguez.

All photographs, unless otherwise noted, are courtesy of Cape Cod National Seashore.

INTRODUCTION

Restless Cape Cod has been so blown and carved by wind and water that the peninsula of sand we walk today is, literally, not the one of a thousand, a hundred, or even 10 years ago. But the spirit is the same. There is one reason, and one reason only, that we can still say of Cape Cod and the sea, as Thoreau did, "it was equally wild and unfathomable always." And that is because of the noble experiment of Cape Cod National Seashore.

If there was one moment when that spirit was nearly lost, it was in 1960. The movement to create a national seashore on Cape Cod had been brewing—sometimes contentiously—since 1939. World War II interrupted such thoughts. Postwar, in 1955, the *New York Times* announced, "Speedway to the Tip of Cape Cod. A superhighway extending from the Cape Cod Canal at the base, to Provincetown at the tip of the Cape . . . will open up new scenic vistas to the tourist this summer and substantially cut down driving time to Cape towns." Then in 1960, the Mel-Con development company bought magnificent Fort Hill in Eastham and began to divide the land into 33 lots and lay out roads. This one event, when brought to the attention of America, brought the political and cultural sea change that saved Cape Cod.

At a December 16, 1960, meeting in Eastham, Charles Foster, state commissioner of natural resources, urged officials to take action, noting that Eastham was "within a day's drive of 50 million people—people who, park or no park, are already seeking this last stretch of unspoiled shoreline in unprecedented numbers." President-elect Kennedy was quoted as saying, "Cape Cod offered one of the last remaining chances to preserve a major recreational area from ultimate destruction."

Competing bills began to appear before Congress, but little was resolved. In April 1961, it was clear that the only way to break through the fog of inaction was to organize land and air tours of the Cape for officials and townspeople to see for themselves what was at stake. Sen. Leverett Saltinstall's assistant Jonathan Moore said, "It was a glorious trip. We flew low over Nauset Marsh and landed at one point on Fort Hill, and we were standing there, arguing about whether Fort Hill should be in the park or out of the park. It was still up for grabs. A subdivision had been laid out, and there were even some stakes outlining a couple of homes." Sen. Alan Bible said, "That decided it for me!"

On August 7, 1961, seven months after becoming president of the United States, John F. Kennedy signed the bill creating Cape Cod National Seashore. "This act makes it possible," he said, "for the people of the United States through their government to acquire and preserve the natural and historic values of a portion of Cape Cod for the inspiration and enjoyment of people all over the United States."

The *Berkshire Eagle* of Pittsfield, Massachusetts, noted: "A great public project that seemed almost hopelessly visionary when first proposed five years ago became a reality in Washington yesterday . . . establishing a 26,666-acre national park on the outer shore of Cape Cod. The bill can probably be labeled the finest victory ever recorded for the cause of conservation in New England."

More than that, it was a breakthrough in the cause of U.S. preservation. Never had a national park been created in a place so extensively inhabited. Others, like Yellowstone or the Grand Canyon, had been carved out of publicly owned wilderness or donated lands. Cape Cod National Seashore (CCNS) proposed to conserve a fragile, still wild place that overlays six established towns. It set up an entirely new mechanism, the first citizens' advisory commission, to help in the management of lands, and it authorized funding for considerable private land acquisition. This became known as the Cape Cod Model. Today CCNS is one of 10 national seashores, including Cape Hatteras, Cape Lookout, Point Reyes, Assateague Island, Canaveral, Cumberland Island, Fire Island, Gulf Islands, and Padre Island.

Cape Cod is unique among them. Conrad Aiken wrote in 1940, "Nature and layering of culture and history are the most essential elements of the Cape Cod character. For hundreds of years, Native Americans, the Pilgrims, fishermen, sailors, poets, dancers, whalers, playwrights, writers, photographers, journalists, politicians, and visitors from all over the United States and the world have traveled to or settled on this small peninsula."

The rich lore of the past is evident everywhere. There are reminders of the Pilgrims in place names like Corn Hill, Pilgrim Springs, and First Encounter Beach. Stories of shipwrecks, like the wreck of the pirate ship Whydah, come alive when even today pieces of ancient shipwrecks wash up on the beaches. The landscape still evokes stories of creaking windmills, lighthouses, and wild cranberry bogs. Stretching so far out to sea, the Cape became a focal point for early communication with Europe. It is here that Marconi first sent wireless messages to England, here that the French Cable Station brought news of Lindbergh's flight in 1927, and the German invasion of France in 1940.

The pantheon of writers and artists drawn to work here is astonishing: Henry David Thoreau, John Dos Passos, Mary McCarthy, Eugene O'Neill, Tennessee Williams, Mary Heaton Vorse, Henry Kemp, Henry Beston, Anne Sexton, Mary Oliver, Edna St. Vincent Millay, Norman Mailer, Elizabeth Bishop, Stanley Kunitz, Marge Piercy, Annie Dillard, Edward Hopper, Mark Rothko, Jackson Pollock, Henry Hensche, Hans Hoffman, Ben Shahn, and Robert Motherwell are only a few of those who have created a rich tradition of the arts on Cape Cod.

Though this landscape has been long inhabited, it has never been domesticated. Over 450 species of amphibians, reptiles, fish, birds, and mammals, and myriad invertebrate animals depend on the diversity of upland, wetland, and coastal habitats found in Cape Cod National Seashore. The park provides habitat year-round, particularly during nesting season, migration, and wintertime. Wildlife here includes the familiar gulls, terns, and waterbirds of beaches and salt marshes and a great variety of animals that inhabit the park's woodlands, heathlands, grasslands, swamps, marshes, and vernal ponds. Some 25 federally protected species occur in the park, most prominently the threatened piping plover. The seashore is a significant site for this species with roughly five percent of the entire Atlantic coast population nesting here. Cape Cod National Seashore also supports 32 species that are rare or endangered in Massachusetts. Some of these, such as the common tern, are conspicuous; far less noticeable is the elusive spadefoot toad which spends most its life buried in the sand, emerging only on warm nights with torrential rainfall.

The protection of both the natural and cultural history of the Cape is a constantly evolving practice. In recent years the park has had to deal with overcrowded sites, traffic congestion, vehicle damage to bird nesting areas, air and water pollution, groundwater extraction and contamination, beach erosion, historic structure deterioration, declining forest land, and the expansion of the Provincetown Airport.

There are some 600 private homes within the park, expansion rules for which were thought to have been settled when the park was created. Yet the zoning guidelines established for structures in the park were just that—guidelines. Each of the six towns in the area was expected to make those guidelines law by modifying zoning laws for land within park boundaries. When Supt. George Price Jr. arrived in 2005, it became clear that only Eastham's zoning had stayed true to the seashore's intent. In one Wellfleet case, a 550-square-foot cottage on a tiny spit of land at the south end of Griffin Island was knocked down in 1984 to build an 1,812-square-

foot home. This property was later knocked down and building has begun on a 5,848-square foot mansion, a 203-percent increase over the 1984 home, and 963-percent over the original cottage. Wellfleet zoning, since changed, was helpless to control this. Superintendent Price has said, "My number one concern is this issue of large houses . . . a sudden assault, if you will."

Looking at the first 50 years of Cape Cod National Seashore, I realize that the Cape is not only Thoreau's "bare and bended arm" battling the forces of the Atlantic and development. It is a hook, a seine, a curved lobster trap, a billowing net that captures everyone who wanders by. Tales are legion of children who spent summers at the Cape and were drawn back year after year, bringing with them their children and grandchildren. The old families are still there, in cedar-shingled homes, and the Kennedys, who have cherished their Hyannis homes for generations, continue to find solace here.

Sen. Ted Kennedy (with Congressman Bill Delahunt) stepped up in 2006 when the North of Highlands Campground in Truro was to be put on the market for possible development. They acquired the first $2 million in funding to preserve the campground—57 acres within the bounds of the national seashore. I suggested we ask Senator Kennedy to consider writing the preface to this 50th anniversary book. On August 25, 2009, I received word that not only would the senator be happy to do so, but that he had graciously offered to write the full introduction. At about 2:00 in the morning, I happened to have the BBC news on the radio when I heard that Ted Kennedy had passed away at his home on the shore of Cape Cod in Hyannis.

Many great writers have written exquisitely of Cape Cod. One unheralded local writer captured its essence with clarity and passion. More than 50 years ago, when the fate of Cape Cod National Seashore was still uncertain, columnist Jerry Burke wrote in the *Yarmouth Register*, "In our shrinking, defiled, and exploited continent we must hold on to the few remaining miles of unspoiled beaches . . . We must not diminish the Great Outer Beach by the length of one gull's wing or the shadow of one beach plum. Let America come here and replenish its soul."

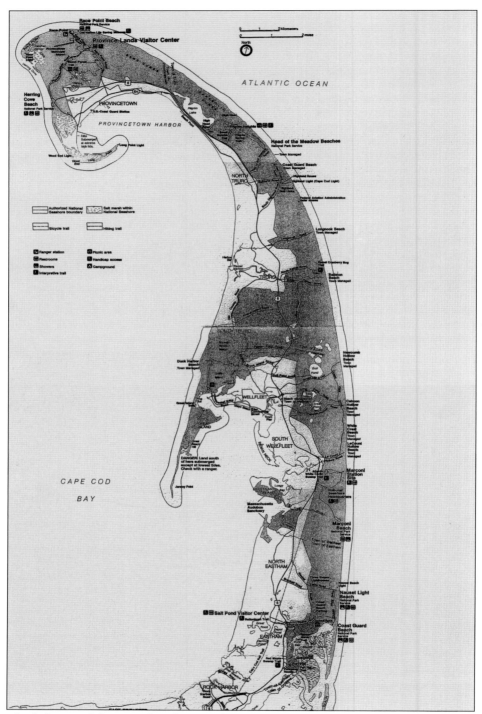

The shaded parts of this map show how much of Outer Cape Cod is protected within Cape Cod National Seashore. Included are about 40 miles of Atlantic Ocean beach, and both ocean and bay sides of Wellfleet and Provincetown.

10

One

WILDERNESS AND THE FIRST PEOPLES

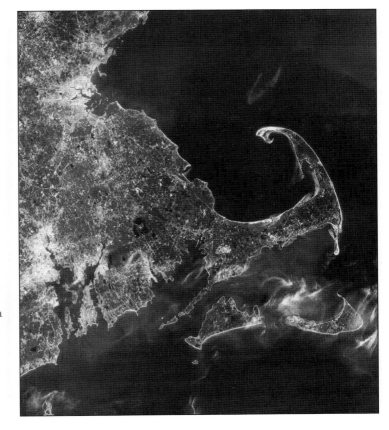

It has been 50 years since Pres. John F. Kennedy signed the legislation that created Cape Cod National Seashore in 1961. Today satellite photographs prove what guidebooks began to note as early as the 1930s: "The visitor from . . . inland America drives down the length of this sandy curlicue, and observes that it is taking him well out to sea, and that in spots it seems to be hanging as if by a thread."

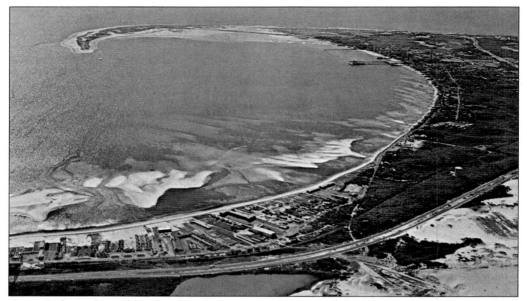

Cape Cod was formed by the glacial advance and retreat of the Laurentide Ice Sheet. About 23,000 years ago, the glacier reached its maximum advance and deposited the gravel, rocks, and sand that created the Cape. Some 18,000 years ago, the ice sheet retreated, the glacial melt caused the seas to rise, and what is known as Cape Cod took its familiar shape.

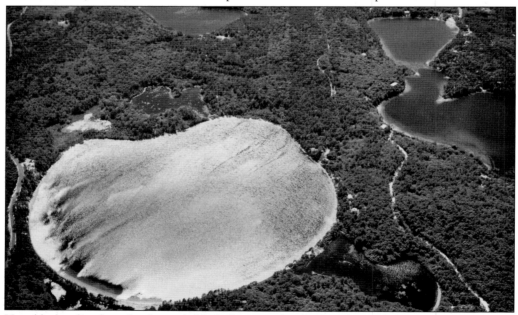

Huge blocks of ice from the glaciers left holes known as kettles that ultimately filled with groundwater. "Our host took pleasure in telling us the names of the ponds, most of which we could see from his windows." Thoreau wrote in his book *Cape Cod* of a memorable visit to an oysterman's house at Williams Pond. "They were Gull Pond . . . Newcomb's, Swett's, Slough, Horse-Leech, Round, and Herring Ponds." Great Pond in Wellfleet is seen here from the air.

12

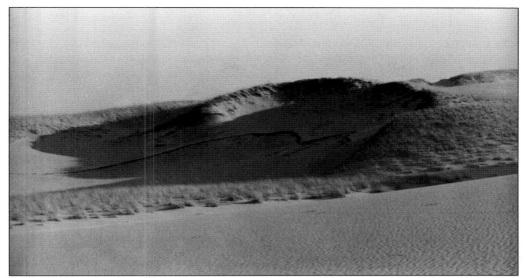

Parabolic dunes, formed when the prevailing west wind blows out the middle of an existing dune, are just one of the remarkable forms nature creates and recreates on the Cape. The forces of waves and wind continue to transport beach and dune deposits, keeping the islands, spits, lagoons, salt marshes, forests, and meadows in continual flux.

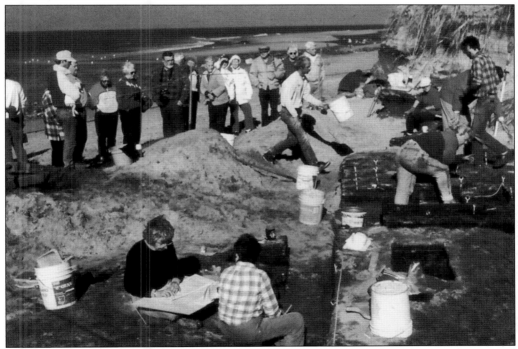

Artifacts excavated from 1990 to 1992 at the Carns Site at Coast Guard Beach in Eastham reveal the presence of Woodland Indians from 2,100 to 1,100 years ago. By 3,000 years ago, people left dense deposits of ancient trash, including discarded stone tools, stone flakes, shell from the gathering of shellfish, fish and animal bone, and ash and stone from fires for cooking and heat. Other sites reveal their presence for nearly 10,000 years.

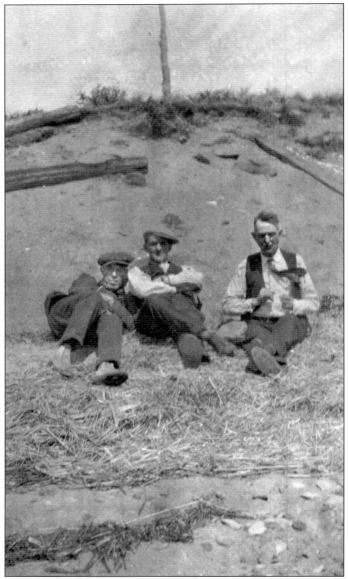

These three men at Indian Neck in Wellfleet were unaware, on July 4, 1927, that Native American remains were buried under the sand. The Indian Neck Ossuary is one of the most important archeological sites on the Cape. Outside the boundaries of CCNS, it was discovered accidentally in 1979, when a backhoe digging a trench for a home improvement project on private land uncovered Native American bones. After determining that the bones were not related to homicide, archeologists from the National Park Service conducted an archaeological salvage excavation to recover the remains. The ossuary, a type of community burial ground in which the bones of several individuals are buried together, contained the remains of at least 56 individuals. Every eight to 12 years, outlying villages would collect remains and return bones to the ancestral village in a ceremonial burial. Evidence of the harvesting of shellfish in the wintertime implies a more established, perhaps year-round, coastal habitation than was previously thought. The burial dates to about 1,100 A.D., but may be as early as 1,000 B.C.

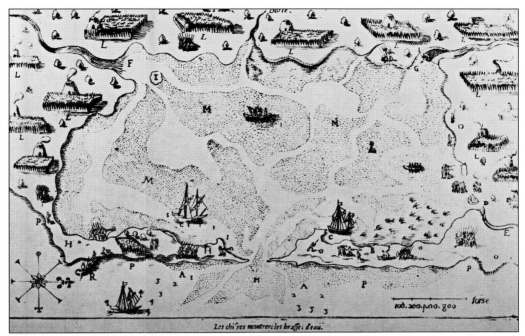

Wampanoag Indians lived throughout much of Cape Cod and many live today. Among them were smaller tribes like the Nausets, who inhabited the southern portion of what would become Cape Cod National Seashore. French explorer Samuel de Champlain sailed into Nauset Harbor in 1605 in search of a site for French settlement. He eventually chose the Quebec area. The map he drew shows some of the 20 to 30 Nauset families he saw in their summer camps along the shore.

On November 9, 1620, the Pilgrims aboard the *Mayflower* sighted Cape Cod. They set anchor in what is now Provincetown and for the next three months explored the cape. They found a freshwater spring in the Truro area, encountered a few Native Americans, and took baskets of Indian corn buried on a hill near the Pamet River. On December 6, Myles Standish and 18 men camped in Eastham, then crossed the bay to the area known today as Plymouth.

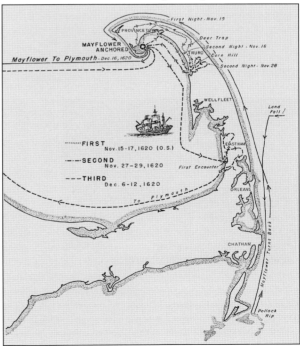

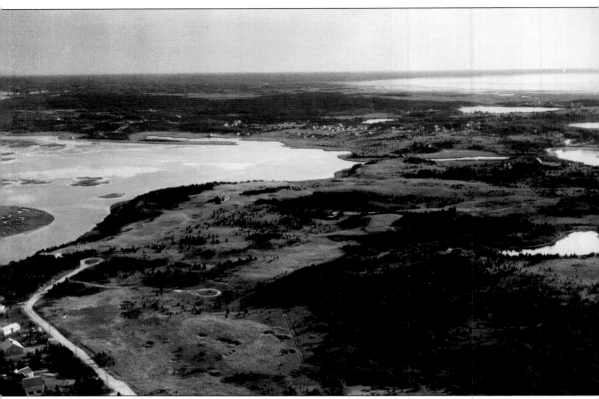

The Pilgrims at Plymouth visited Nauset many times after 1620 to buy food and trade. As with earlier European explorers, they spread diseases for which the Native Americans had no immunity. Many of the Nauset Indians died, and the population declined drastically. In 1639, about half the English in Plymouth relocated to the Nauset area (seen here), settling the town that is now Eastham. *Mayflower* passenger Constance Hopkins and her husband, Nicholas Snow, were the first known European settlers on Billingsgate Island in Wellfleet Harbor in the 1640s. In 1645, a group of purchasers from Plymouth were granted the land for what are now the towns of Wellfleet, Eastham, and Orleans.

Two

THE ROMANCE OF
OLD CAPE COD

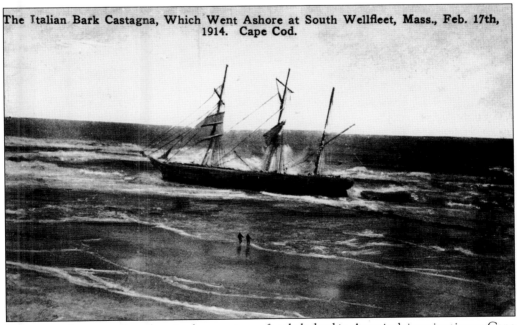

The Italian Bark Castagna, Which Went Ashore at South Wellfleet, Mass., Feb. 17th, 1914. Cape Cod.

There is perhaps no other place in the country as firmly lodged in America's imagination as Cape Cod. Patti Page's *Old Cape Cod* was a huge hit in 1957, just when the movement for a national seashore was gaining momentum. More than "the taste of a lobster stew / Served by a window with an ocean view," Cape lore includes tragedy like the shipwreck of the *Castagna*, above, on which the cook and the cabin boy died frozen aloft in the rigging.

Long before Cape Cod's famous whalers set sail for the far corners of the world, the Cape's native peoples were whaling from its shores. In 1605, Capt. George Waymouth watched them capture a live whale. He wrote, "They divide the spoil . . . and when they boil them, they blow off the fat, and put [in] their pease, maize, and other pulse (legumes) which they eat." This early whaling was limited to driving ashore whales or killing those that were stranded.

Shore whaling was practiced by Cape Codders until about 1750, when the pilot whale population declined. In 1794, the Rev. John Mellen of Barnstable wrote, "Seventy or eighty years ago the whale bay fishery was carried on in boats from shore, to great advantage. This business employed nearly two hundred men for three months of the year, the fall, and the beginning of winter. But few whales now come into the bay."

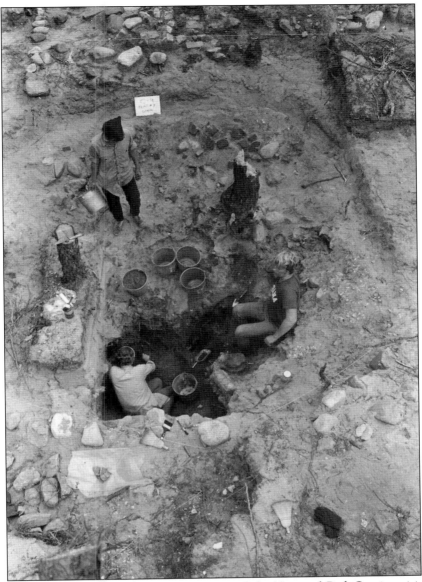

In 1969, archaeologists from Plimoth Plantation and the National Park Service visited Great Island, on the western side of Wellfleet Harbor. There they investigated evidence of a building that had been a tavern and housing for shore whalers. A major excavation in 1970 initially unearthed bits of ivory fans, whale bone, drinking vessels, clay pipes, and ceramics. Eventually some 24,000 artifacts were recovered, proving the existence of a very large tavern, in use from the late 17th century until the end of shore whaling in the mid-18th century. Archaeologists uncovered a whale vertebra that had been used in the tavern as cutting block, the bones of a whale flipper, and the foreshaft of a harpoon. There were large quantities of dark green glass fragments from wine bottles, and what may be the oldest piece of scrimshaw in New England, the carving of a man's head wearing a cap. The most chilling discovery was the frontal bone of a man's skull, with enough cuts and slashes to indicate he had been murdered. Great Island is just one of the treasures protected by Cape Cod National Seashore.

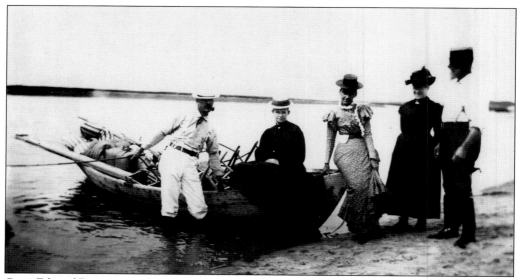

Capt. Edward Penniman, of Eastham, is pictured above at far right hosting a family beach party in the 1890s. In 1842, Penniman went to sea at the age of 11 as a cook. When he was 21, Penniman shipped as a harpooner aboard the New Bedford whaleship *Isabella*. By 1860, he was captain of the bark *Minerva*. Penniman undertook whaling voyages to both southern and Arctic latitudes and was often absent four years at a time. His wife, Augusta Knowles Penniman, accompanied him on some voyages and left detailed, illustrated accounts. By the time Penniman retired in 1883, he had made seven voyages as a whaling captain.

In 1868, Capt. Edward Penniman built a distinctive French Second Empire house on the south side of Fort Hill in Eastham, overlooking the ocean and the bay. For many years, the jawbones of a whale formed the gate of a walkway leading to the back door. The Penniman House is open to the public as part of Cape Cod National Seashore.

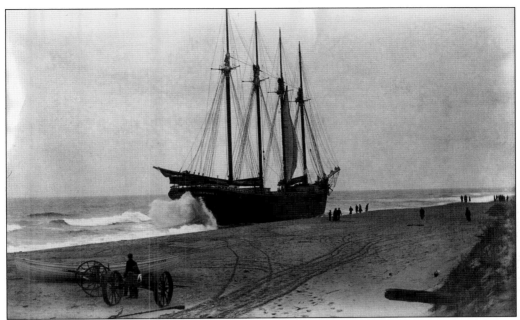

The schooner *Charles A. Campbell*, seen here, was stranded off Truro at 4:00 a.m. in 1895 during a thick fog. Until the first Cape Cod Canal was built in 1914, the treacherous waters off the Cape had claimed more than 3,000 ships. So many ships have gone down on the hidden sandbars off the coast between Chatham and Provincetown that those 50 miles have been called an ocean graveyard.

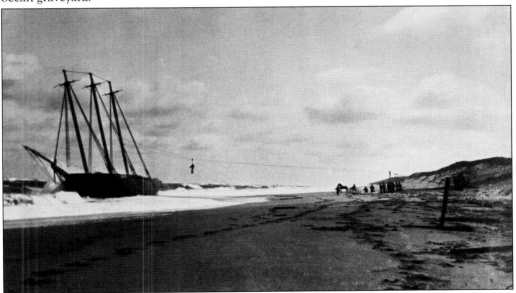

The crew of the *Hannah E. Shewbert*, above, was rescued by the men of the Cape Cod Life Saving Stations. The first recorded Cape Cod wreck was the *Sparrowhawk*, which ran aground at Orleans in 1626. In 1861, Isaac Small became a marine reporting agent at Highland Light in Truro. He wrote, "The whitened bones of hundreds of dead sailors lie buried in the drifting sands of this storm-beaten coast."

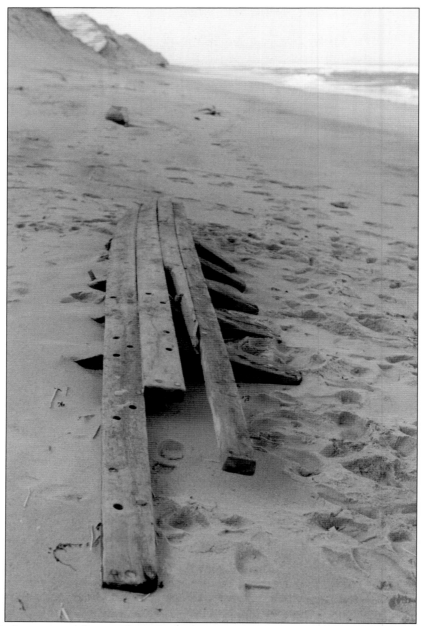

In 1992, this piece of shipwreck washed ashore at Cahoon Hollow in Wellfleet, a reminder of the famous ship *Whydah* that wrecked near here in 1717. The site of the wreck was discovered in 1984 by underwater explorer Barry Clifford. The *Whydah*, considered the world's only verified pirate shipwreck, has yielded thousands of artifacts, including coins, jewelry, pistols, and swords. Also found were the fibula, silk stocking, and shoe of John King, who, at no more than 11 years old, was the youngest member of the ship's crew. The ship's captain, Sam Bellamy, had plundered vessels in the West Indies, where he captured the *Whydah*. He flew a large black flag with a death's head and crossed bones. Not far from Nantucket, he captured two more ships before he met his death in the wreck of the *Whydah* off Wellfleet.

In the early 1800s, there was an average of two wrecks every month during the winter. If a sailor managed to get ashore on a winter night, he would likely freeze to death after he got there. In 1797, the Massachusetts Humane Society started putting up huts, like the one pictured, along the most dangerous sections of the Massachusetts coast in the hope that stranded sailors would find them and take shelter.

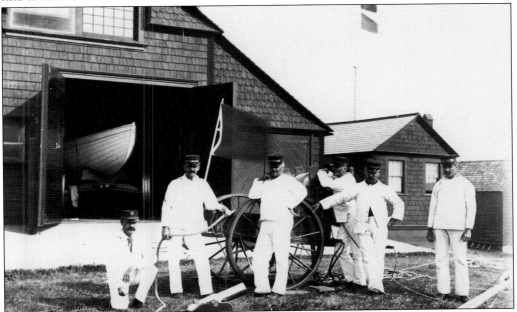

It was not until 1872, however, that a really efficient lifesaving service was put into operation by the U.S. government. Stations were erected every 5 miles on the beach. Six or seven surfmen and a keeper lived in each station and kept a continuous lookout. At night, two men from each station walked the beach on patrol, met at a small halfway shelter between stations, and then returned by their same route.

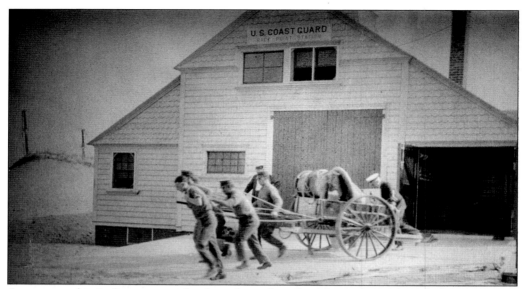

As soon as a ship in distress was sighted, a red signal was fired from ashore. Then the lifesaving crew went into action. If the sea permitted, they launched their surfboats. If not, and if the shipwreck was near enough to shore, the lifesaving team stayed on the beach and pulled the sinking crew to shore, one by one, in a breeches buoy (a buoy with canvas pants attached as a sort of harness to secure the person being rescued). This was connected to a double line with pulley that was strung high over the water, similar to a modern-day zip line.

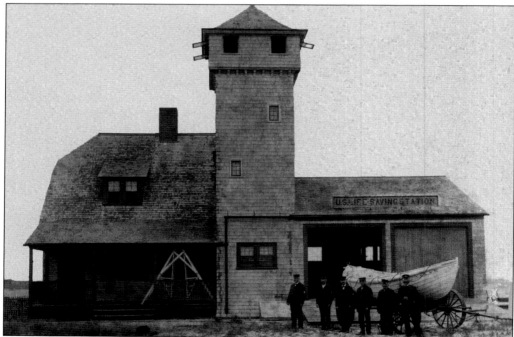

The Old Harbor Life Saving Station was located at North Beach in Chatham and served as a station until 1944. After use as a private fishing camp, the National Park Service acquired it in 1977. Threatened by shoreline erosion, it was moved to the east end of Race Point and is still standing.

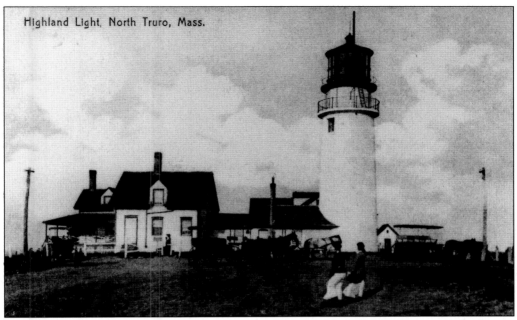

Highland Light, North Truro, Mass.

A notorious storm buried Cape Cod under 6 feet of snow in November 1789. Seven vessels were driven ashore, and there were no survivors. Some 25 bodies were recovered from the beaches. Eight years later, the original Highland Light was built in Truro. It was the first of 18 lighthouses on Cape Cod, in addition to three on Nantucket, five on Martha's Vineyard, and two on the Elizabeth Islands.

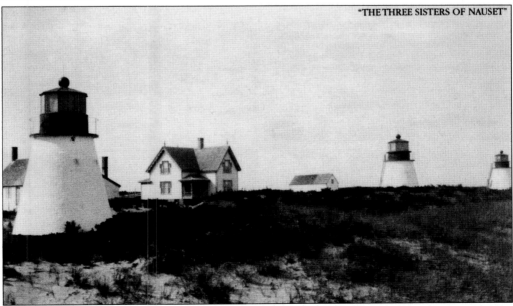

"THE THREE SISTERS OF NAUSET"

The lighthouses at Nauset Beach in Eastham have had a long and evolutionary past. In 1838, three brick towers were built in a row 150 feet apart on the cliffs of what is now the Nauset Light Beach area. Known as the Three Sisters, the original brick towers fell victim to erosion in 1892 and were replaced with three movable wooden lighthouses.

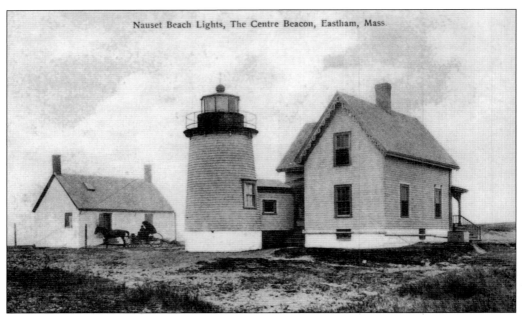

Nauset Beach Lights, The Centre Beacon, Eastham, Mass.

In 1911, two of the wooden "sisters" were sold. The one remaining light became known as "The Beacon," seen here. In 1923, The Beacon was retired. It was replaced by one of the two paired lighthouses in Chatham, which was dismantled and moved to Eastham. Reconstructed about 200 feet from the edge of the cliff, it was renamed Nauset Light. The Three Sisters are now arranged in their original configuration in the woods just off Cable Road in Eastham.

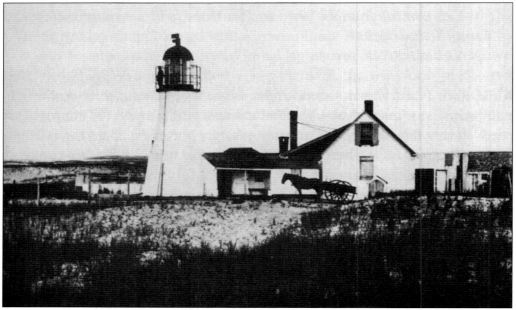

As early as 1808, Provincetown's residents asked for a lighthouse at Race Point, but it was not until 1816 that it was built. The rubblestone tower's light was 25 feet above sea level, and it had one of the earliest revolving lights in an attempt to differentiate it from other lighthouses on Cape Cod.

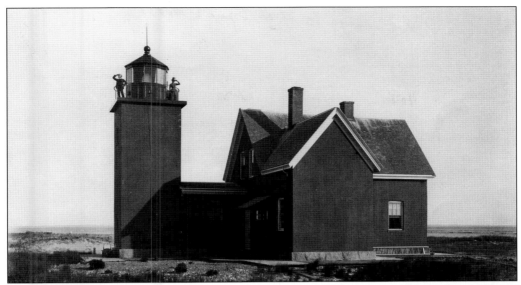

The Billingsgate Lighthouse was built in 1822 and gone 100 years later. The 50-acre island of Billingsgate was south of Wellfleet's Great Island until erosion carved it down to a shoal. The diary of Herman Dill, last keeper, told part of the story. An entry dated November 17, 1875, states, "I do not know but the Island will All wash away." In his final entry, dated March 26, 1876, he wrote, "The very worst storm for the winter was Last Night." Dill tried to leave the island but was found dead in his dory the following day.

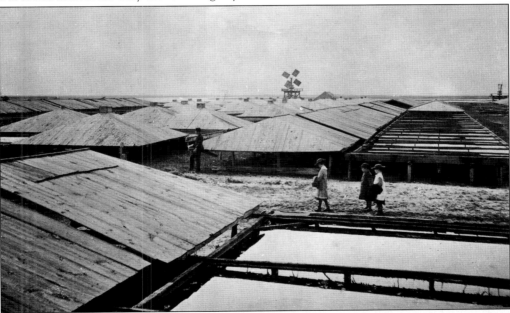

Windmills have long been a romantic part of old Cape Cod. For a time, literally hundreds of small windmills lined the shores for saltmaking. The mills pumped seawater into shallow vats (pictured above) where evaporation left sea salt. (The vats were covered in rainy weather.) In 1837, there were 78 such saltworks in Provincetown alone. Before refrigeration, huge amounts of salt were needed to preserve cod and mackerel.

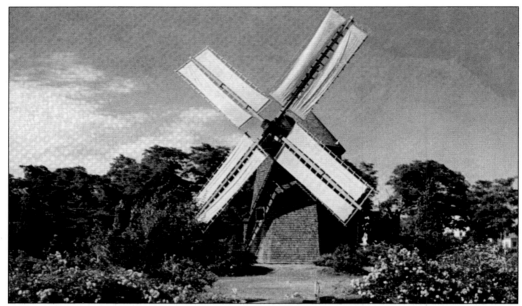

Life in Cape Cod villages used to revolve around windmills, where getting one's daily bread was a communal activity. Among the most prominent remaining is the Eastham Windmill (above), built in about the 1680s. Farmers brought corn, wheat, and rye to local windmills, which were often among the first structures in any shore town. In Truro's earliest years, the principal buildings were its windmill and two meetinghouses.

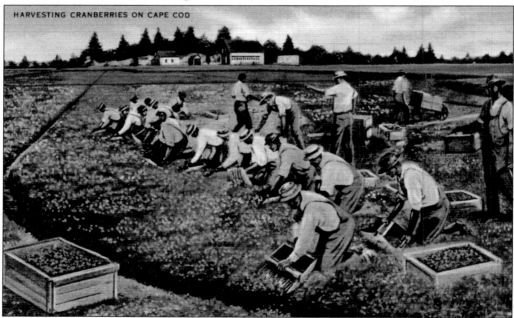

HARVESTING CRANBERRIES ON CAPE COD

Cape Cod National Seashore protects both wild and cultivated cranberry bogs, notably in Truro and the Provincetown dunes. At its peak, the Pamet Cranberry Company of Truro harvested 166 barrels of cranberries in a single fall season. Emerging wetland and upland vegetation is enveloping the former bog, with only the historic Bog House standing as a reminder.

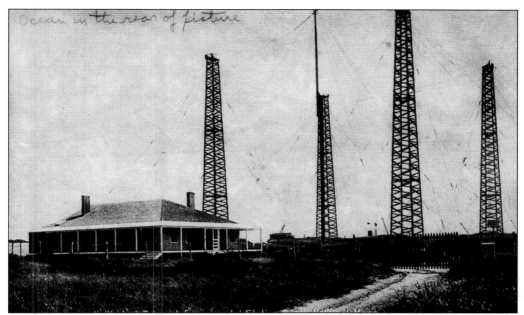

Global wireless communication can be traced back to January 18, 1903, when Guglielmo Marconi sent the first two-way transatlantic wireless message from South Wellfleet. In 1909, Marconi and a colleague were awarded a joint Nobel Prize in physics for their contributions to the development of wireless telegraphy. The South Wellfleet Station linked the *New York Times* and *London Times* for quick international news. In fact, it was the technology pioneered at Marconi's station that made it possible for the *Carpathia* to rescue 712 passengers from the *Titanic* in 1912.

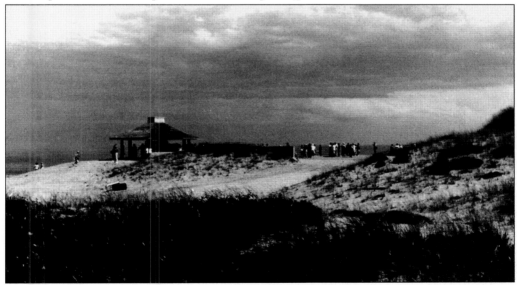

Most of the Marconi station is gone now, after being threatened by the pounding of the Atlantic Ocean. The sea was taking 3 feet each year, quickly approaching the easternmost towers. The navy closed the station in 1917, and what was left was dismantled in 1920. Cape Cod National Seashore celebrates Marconi's achievements with exhibits and programs, and by preserving what is now called Marconi Beach.

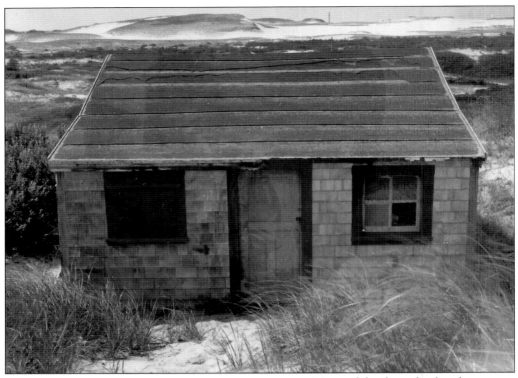

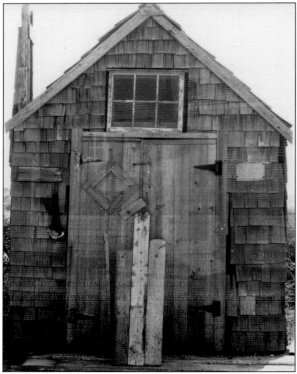

Many of the dune shacks of Provincetown and Truro's backshore have been saved as part of the seashore's mission to preserve the culture of the Outer Cape. These weathered, rustic shacks are reminiscent of the charity huts kept for shipwrecked sailors by the Massachusetts Humane Society. Most began as the fishing shacks. For generations they have drawn artists, writers, mavericks, and lovers of raw, natural Cape Cod.

Harry Kemp, "The Poet of the Dunes," used a dune shack for many years before his death in 1960. Born in Ohio, Kemp ran away to sea at the age of 16 as cabin boy on the German ship *Castle*, bound for Australia. Just before World War I, he established himself in the summer artist colony of Provincetown. Kemp played one of the seamen in Eugene O'Neill's Provincetown production of *Bound East for Cardiff* in 1916.

As of 2004, there are 19 remaining dune shacks scattered over 3 miles of shoreline, with about 250 dune dwellers. Today a dedicated group of families, individuals, and nonprofit organizations carry on a unique heritage of art, reflection, and nature study at the dune shacks in Provincetown and Truro.

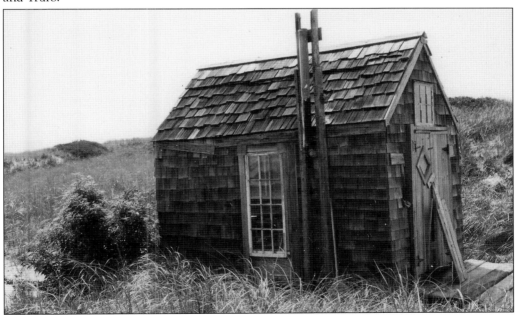

These words from Harry Kemp's poem "The Wreck" describe a sight seen near the old dune shacks: "Seared bone-white by the glare of summer weather, / Cast side-long, on the barren beach she lies, / She who once brought the earth's far ends together / And ransacked East and West for merchandise. / The sea-gulls cluster on her after-deck / Resting from the near seas that wash and fall."

On October 9, 1849, Henry David Thoreau and a good friend set out for the Cape from Concord, Massachusetts. This and future excursions were chronicled in Thoreau's book *Cape Cod*, the most famous Cape narrative in literature. "The Great Beach," he wrote, "is . . . probably the best place of all our coast to go to . . . I do not know where there is another beach in the Atlantic States, attached to the mainland, so long, and at the same time so completely uninterrupted."

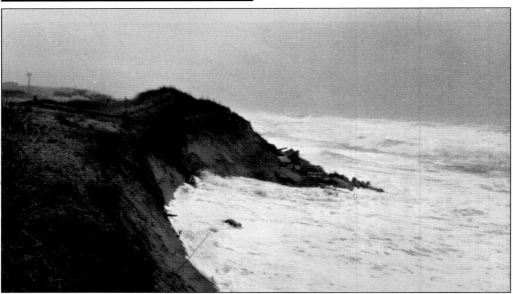

After a night at the Samuel Higgins Tavern in Orleans, Thoreau wrote, "It rained as hard as ever; but we were determined to proceed on foot, nevertheless . . . We first made some inquiries [about] walking up the shore on the Atlantic side to Provincetown . . . Higgins said that we could go very well, though it was sometimes . . . dangerous walking under the bank, when there was a great tide, with an easterly wind, which caused the sand to cave."

Henry Thoreau described the "bare-armed, clenched fist" of the Cape as "boxing with northeast storms . . . and heaving up her Atlantic adversary from the lap of the earth." He stayed in the house of Wellfleet oysterman John Young Newcomb at Williams Pond in 1849. The house, still standing, is within CCNS and is privately owned. Thoreau wrote, "[Oysters were annually] brought from the South and planted in the harbor of Wellfleet, till they attained 'the proper relish of Billingsgate'. . . The old man said that the oysters were liable to freeze in the winter if planted too high; but if it were [not] so cold as to strain their 'eyes' they were not injured . . . 'Can an oyster move?' I inquired. 'Just as much as your shoe,' he replied. But when I caught him saying that they 'bedded themselves down in the sand flat side up, round side down,' I told him that my shoe could not do that without the aid of my foot in it."

South of Coast Guard Beach in Eastham stood the cottage where Henry Beston lived while gathering the material for his classic book, *The Outermost House*, published in 1928. Spiritually shaken by his experiences in World War I, Beston retreated to the Great Beach in search of peace and solitude. Beston designed the "outermost house," sometimes called the Fo'c'sle, in 1925. "Nature is part of our humanity, and without some awareness of that divine mystery man ceases to be man," he wrote.

The book describes life on the Great Beach during all four seasons. Beston had enormous faith in and respect for nature. In *The Outermost House*, he wrote, "East of America, there stands in the open Atlantic the last fragment of an ancient and vanished land. Worn by the breakers and the rains, and disintegrated by the wind, it still stands bold." It was hardly unexpected when the sea claimed the Outermost House during a fierce northeasterly storm in the winter of 1978.

Three

THE LOSS OF INNOCENCE

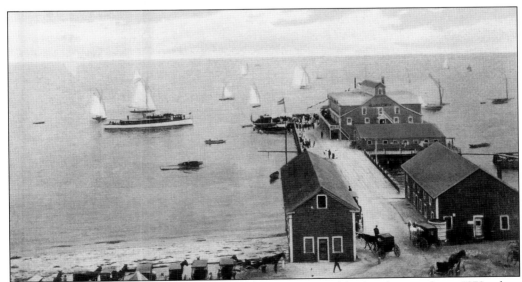

Passion for the romantic narrative of Cape Cod can be traced back at least as far as 1873, when the railroad reached Provincetown. As the country turned from fishing and farming to industry, more families could afford escapes to the sea. The overfishing and deforestation of the first 200 years was followed by the first Resort Era, from the 1870s to the 1930s. Pleasure boats and summer resorts, like the Chequessett Inn (above) at Wellfleet, shared the same shores as the houses and weathered boats of the fishermen.

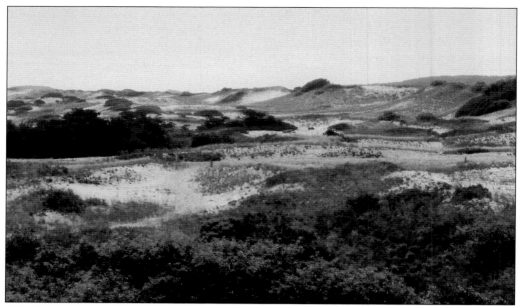

The original pine-oak forests were almost totally gone by the 20th century. European settlers had been cutting forests for fuel and house and boatbuilding from 1650 to 1900. The threat was recognized early. In 1696, the proprietors of what is now Truro ordered "that henceforth there would be no cordwood or timber cut upon any of the common or undivided land." Such orders barely slowed the destruction. For example, Great Island and the surrounding area had been stripped of wood by 1711.

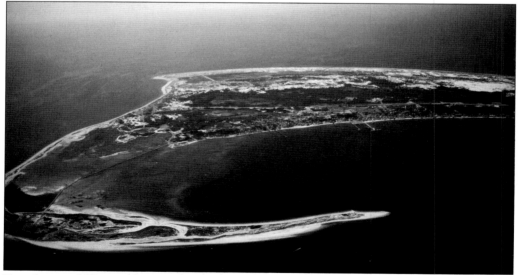

Fear that sand blowing from deforested Provincetown would fill the harbor there led, in 1714, to the Massachusetts General Court proclaiming "an Act for preserving the Harbor . . . and Regulating the Inhabitants and Sojourners there." The act created the "Province Lands," still a protected part of the national seashore. Over the past 100 years, much of the upland forest on the Cape has grown back, especially on national seashore lands, which are protected from housing development.

When the mosquito population threatened the growth of tourism, many of the Cape's marshes were diked. In 1907, the *Boston Herald* announced that "Wellfleet, one of the prettiest towns on Cape Cod, is 'stung.'" Wellfleet's Herring River was diked to control mosquitoes in 1908. Today the estuary is being restored. Cape Cod National Seashore includes over 2,500 acres of historically diked salt marshes. Work continues to restore these degraded estuaries.

Bird shooting clubs developed along with commercial hunting of waterfowl and shorebirds. One report counted 8,000 golden plovers and curlews shot in one day on the Cape. In addition, the draining of salt marshes took their toll on bird habitats. Both the Federal Migratory Bird Treaties of 1916 and the creation of Cape Cod National Seashore have gone a long way to restore the Cape's rich bird populations.

As America prospered after World War II, seaside vacations became within reach of millions. In 1955, the *New York Times* announced the completion of Route 6: "Speedway to the Tip of Cape Cod—Super Highway Opens Up." In 1959, the U.S. Department of the Interior published *Cape Cod National Seashore: A Proposal.* "Without immediate preservation of the Cape's natural features . . . there is great danger that the . . . qualities which have drawn increasing numbers to the Cape each year will soon be lost for all time, consumed by commercialization and real estate subdivisions."

Some Cape Cod towns made detailed plans for expansion. In 1959, Provincetown officials hoped to set aside acreage for development in the West End. Town manager Walter Lawrence organized a master plan for the town. The plan called for filling in marshlands, building a golf course, and high-rise apartments. In opposition, the Emergency Committee for the Province Lands was formed. The proposed master plan never made it to town meeting.

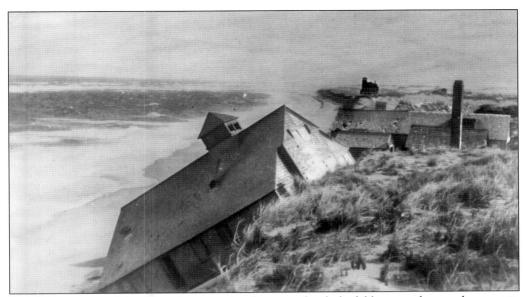

Since the creation of this magnificent peninsula, nature has lashed, blown, and scraped away at it. Major storms can destroy islands (like Wellfleet's Billingsgate Island) and create or destroy sandbars and dunes. The cape continually changes, despite people's best efforts to control it. In 1931, a storm weakened the old Peaked Hill Bars Coast Guard Station, where playwright Eugene O'Neill had once lived. The following year the building, pictured above, tumbled into the ocean.

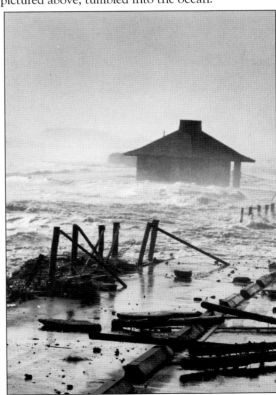

The Great Blizzard of 1978 destroyed both the parking lot and the bathhouse at Coast Guard Beach. On February 6–7, hurricane-force winds and tides 15 feet high slammed Cape Cod. Most of the cottages and 90 percent of the dunes at Coast Guard Beach were washed to sea, and Monomoy Island was severed in two.

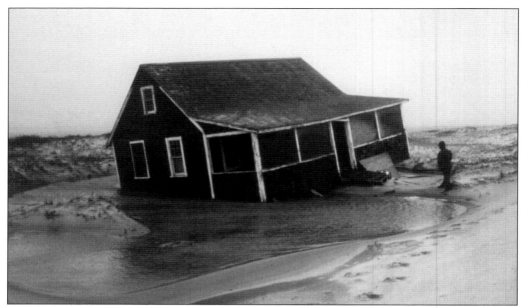

Above is one of the many cottages washed offshore in the blizzard of 1978. Over 10,000 people were evacuated from the New England coast. The five-man crew of a North Shore pilot boat vanished, and the Gloucester boat *Can Do* lost its navigation equipment in 30-foot waves. The bodies of the crew washed up on the beaches. A Coast Guard helicopter evacuated the 32-man crew of the tanker *Global Hope* off Salem.

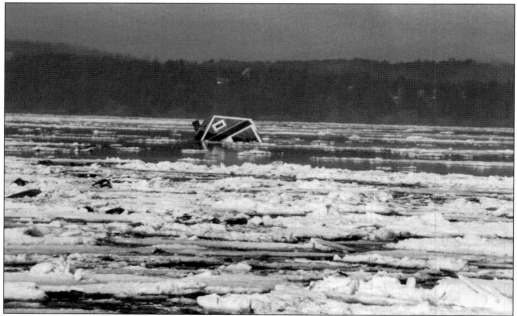

Like this cottage, Henry Beston's Outermost House was lost in the blizzard. Wallace Bailey, director of the Massachusetts Audubon Society, said of the house, "Strongly built and sturdy to the end, it quit its foundation posts and floated into the marsh. People watching through the fog from Fort Hill could see it, gable-deep but upright in the churning inland sea."

Four

PRELUDE TO CAPE COD NATIONAL SEASHORE

The first official proposal to create a Cape Cod National Seashore came in 1939. National Park Service planning consultant Thomas H. Desmond wrote, "The upper arm of the Cape from Eastham to Provincetown is largely undeveloped, outside of a few small villages . . . It consists of scrub oak and pitch pine areas, with a number of freshwater ponds, and great bluffs on the ocean shore, rising in places more than a hundred feet above the surf . . . It is very little occupied, but it is only a question of a short time before it will become exploited unless it can be saved by public purchase."

Thomas Desmond had proposed in 1939 that the National Park Service spend $400,000 for Lower Cape land at $10 an acre. After the bombing of Pearl Harbor, funding for the National Park Service was slashed, and budgets did not begin to recover until 1956. The conservation movement in Massachusetts, however, was gathering support. In 1953, Francis W. Sargent, the new commissioner of natural resources, issued a long-range plan for acquisition of state parks in which preservation of Cape Cod lands was critical.

The National Park Service published *Our Vanishing Seashore* in 1956, based on a survey of 3,700 miles of coastline from Canada to Mexico. "The seashore," it stated, "has become Big Business . . . resorts are mushrooming throughout the length of the coast. Plans on drawing boards call for large scale centers to occupy remote beaches as yet undisturbed by the blade of the bulldozer . . . the Great Beach area of Cape Cod merits preservation as a major public seashore of the North Atlantic coast."

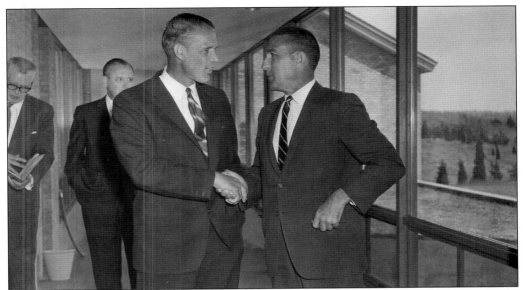

In March 1957, representatives of the National Park Service met in Orleans with state and local officials to propose a national seashore for the Cape. It was attended by Frances W. Sargent, Massachusetts commissioner of natural resources (above right with Secretary of the Interior Stewart Udall), state senator Edward C. Stone, state representative Harry Albro of Harwich, and about 40 people from surrounding towns. On April 8, 1957, Congressman Philip Philbin introduced H.R. 6720, the first bill proposing Cape Cod National Seashore.

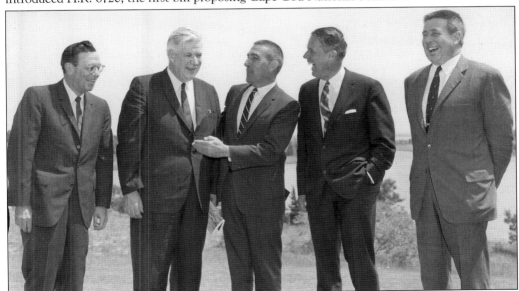

Congressmen Edward Boland and Tip O'Neill (shown above, from left to right, with Stewart Udall, Frances Sargent, and Benjamin Smith) introduced additional bills to create Cape Cod National Seashore on May 12, 1958. Cape residents remained wary. In fact, one federal official jested, "The Cape Codders burned Boland and O'Neill in effigy because of their bills." In 1959, Sen. Richard Neuberger introduced an Omnibus bill proposing three national seashores in the United States. Then Sen. James Murray proposed a "Save Our Seashores" bill to create 10 of them.

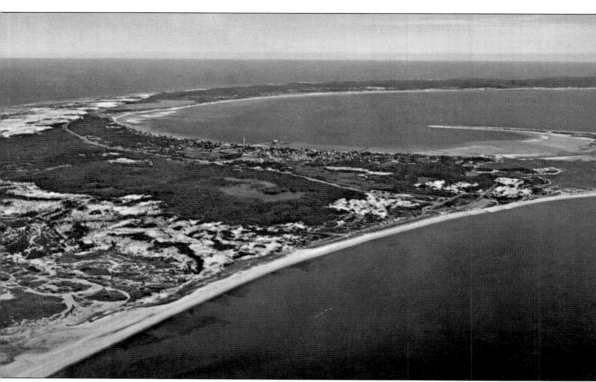

Aerial views like this one of the tip of Cape Cod helped convince legislators to protect the peninsula. On the state level, enthusiasm grew: Early in 1958, Gov. Foster Furcolo came out in support of the national seashore bills. In April, both houses of the Massachusetts Legislature adopted a resolution to establish Cape Cod National Seashore. Late in 1958, the U.S. Department of the Interior issued *Cape Cod: A Proposed National Seashore, Field Investigation Report.* It concluded, "Cape Cod is the most prominent peninsula on the Atlantic Seaboard. Valued for its beautiful scenery, its wealth of plant and animal life, its interesting geology, and colorful history, this seaward extension of Massachusetts has become one of New England's most famous vacation areas . . . The charms of wild beach, heath, forest, and pond are being obliterated by developments. Nevertheless . . . the outer part of Cape Cod [possesses] not only the last expanse of uninterrupted natural beach of its size in New England but one of the finest ocean shores along the Atlantic Coast."

WHICH SHALL IT BE?

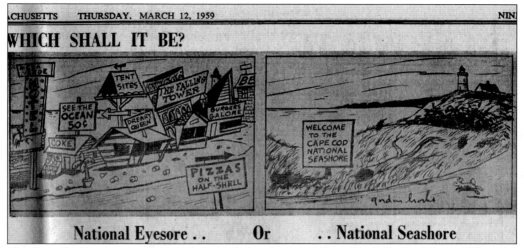

National Eyesore . . Or . . National Seashore

The *Cape Codder* threw its support behind the seashore on March 12, 1959: "Let's face it! We—the people who own and live on Cape Cod—are losing a little more of it each year, each month, each week. Are there any who cannot see the creeping desecration, the impinging blight that chews like disease into area after area? This can go on for just so long. Then, one day, there will be no remoteness, no beauty left . . . Let's cut the knot and save the Cape we love."

Many on the Cape, concerned about loss of local ownership, about taxes, and about space for town expansion, remained opposed. Hundreds of people turned out at public meetings at Eastham Town Hall (above) on March 23, 1959, and again in April, and at Chatham on March 24, 1959. One man argued, "The family is the basic unit of our society, and you are proposing to take homes. That will destroy families. The Communist doctrines set forth the idea of destroying families first."

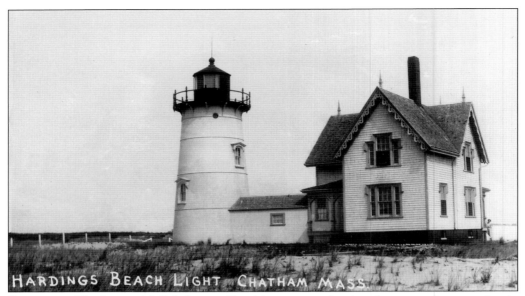

HARDINGS BEACH LIGHT, CHATHAM, MASS.

Picturesque Chatham, with lighthouses like this one, was the site of a contentious meeting in March 1959. When National Park Service director Conrad Wirth approached the high school parking lot for a public meeting with Cape residents he was unrecognized. The parking attendant suggested he hurry because "they're going to give that guy [Wirth] hell!" Wirth came away from the meeting with an appreciation of the Cape Codders' feelings about home rule, yet he said, "I'm an optimist."

Low Tide at the Milton Hill Cottages, Wellfleet, Mass.

Cape Cod National Seashore was to be something new in America. Never before had large numbers of private homes and commercial properties been included in a national park. But opposition from many quarters was high. Officials from several towns formed an anti-park group, led by a Wellfleet selectman. The pastor of the Wellfleet and Eastham Methodist churches, Rev. Earl B. Luscombe, said, "Men of the lower Cape, come, meet the foe, cast off all lethargy; arise to meet the present hour!"

Four

JOHN F. KENNEDY AND THE CAPE COD MODEL

BEACH SCENE, CAPE COD. STREET SCENE, HYANNIS.

Since Joseph Kennedy first rented a Hyannis Port summer cottage in 1926, the Kennedy family has been intimately connected with Cape Cod. Sen. Ted Kennedy made the Kennedy Compound his permanent residence from 1982 until his death in 2009. As a state senator, John F. Kennedy was a strong supporter of preserving the Cape Cod shore within a national park. On September 3, 1959, he and Sen. Leverett Saltonstall introduced legislation to establish Cape Cod National Seashore.

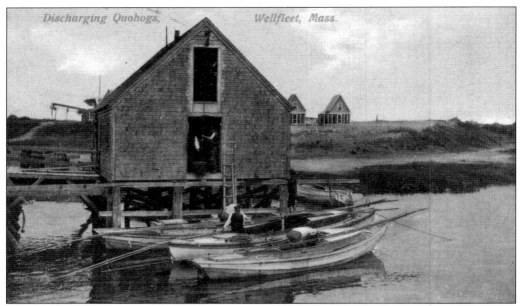

Senator Saltonstall stated the dilemma of the seashore succinctly: "The most important and complicated problem before us is to preserve the scenic and historic features of Cape Cod without injuring and unduly restricting the towns and individual citizens directly concerned." The national seashore would include extensive inland acreage as well as the Great Beach. Half of Wellfleet would be included, a stretch from the Atlantic to Cape Cod Bay.

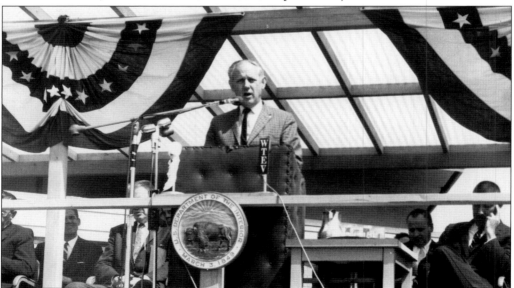

Cape Cod congressman Hastings Keith (seen above at a dedication ceremony) sponsored an identical bill in the House of Representatives on the same day that Kennedy and Saltonstall introduced theirs. The resulting Kennedy-Saltonstall-Keith bill was groundbreaking. This was the first time Congress would authorize the purchase of a national park, including the private homes there. Other parks, like the Great Smokies, had been created from thinly populated land already owned by the government or donated.

The Kennedy-Saltonstall-Keith legislation was also unique in that it provided payments in lieu of taxes to the towns to account for the private property acquired. In a departure from park service practice, hunting and fishing would be allowed within the park. Moreover, a 10-member advisory commission, made up of representatives of the six towns, the state, the county, and the U.S. Department of Interior would be established to guide the national seashore.

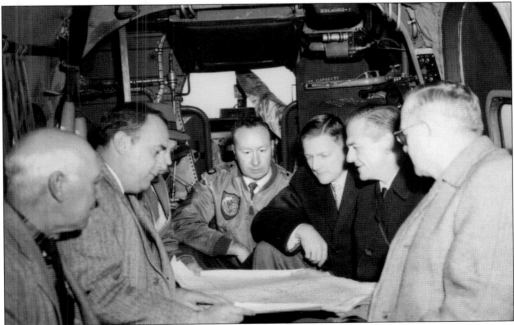

On December 9, 1959, this group prepared to take off from Camp Wellfleet to fly over the proposed Cape Cod National Seashore. From left to right are Selectman John Worthington of Truro, Selectman John Snow of Provincetown, Edward Martinson of the National Park Service, Lt. Col. James A. Harwell of Otis Air National Guard, Massachusetts commissioner of natural resources Charles H. W. Foster, Sen. Frank E. Moss of Utah, and Selectman Maurice Wiley of Eastham.

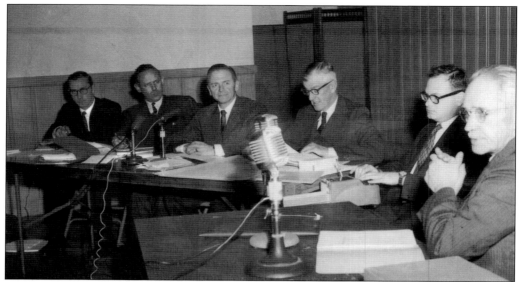

On December 9–10, 1959, a subcommittee of the U.S. Senate held hearings at the Eastham Town Hall auditorium. From left to right are Richard Callahan (chief clerk), Ninth District congressman Hastings Keith (chairman), Sen. Frank E. Moss of Utah, Sen. Leverett Saltonstall of Massachusetts, an unidentified stenotypist, and Selectman Robert McNeece (presenting the point of view of the majority of the Chatham Board of Selectmen). (Courtesy of William Quinn.)

In March 1960, the economic impact study for the proposed park was released by the National Park Service, which helped allay some fears. Hearings were held on June 21 in Congress before the Subcommittee on Public Lands of the Committee on Interior and Insular Affairs. In November, John F. Kennedy beat Richard M. Nixon and was elected president. On December 16, 1960, the House Subcommittee on Public Lands opened two more days of meetings at Eastham Town Hall.

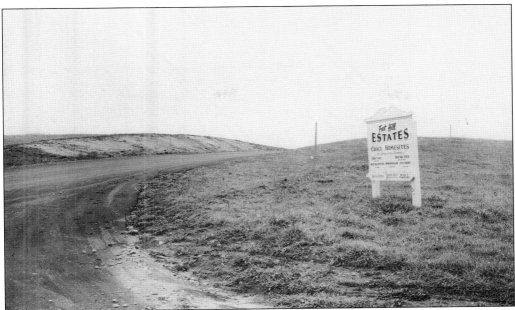

Originally the site of the Knowles family farm, the Fort Hill area was purchased in 1960 by Mel-Con, a development company that began laying out roads and planned to divide the property into 33 lots. The formation of Cape Cod National Seashore discontinued development. The Nauset Moors farmhouse is the only part of the property that remains in private hands.

At the December 16, 1960, meeting in Eastham, Charles Foster, state commissioner of natural resources, urged officials to take action. "May I remind the committee again that the location of this hearing is within a day's drive of 50 million people—people who, park or no park, are already seeking this last stretch of unspoiled shoreline in unprecedented numbers." President-elect Kennedy said, "Cape Cod offered one of the last remaining chances to preserve a major recreational area from ultimate destruction."

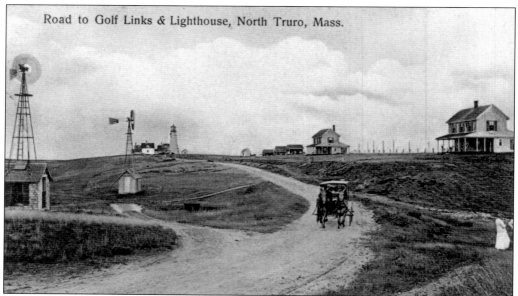

Road to Golf Links & Lighthouse, North Truro, Mass.

S. Osborn Ball, a lawyer with extensive beachfront property in Truro said, "Please don't be misled by my initials. I think the time has passed when we old timers can hope that Cape Cod will stay the way it is. The rape of this beloved country has begun in earnest . . . It is going to change. Should it be done by bulldozers? By money-mad people? By builders wanting quick jobs? Or is it to be done by the U.S. government in another manner?"

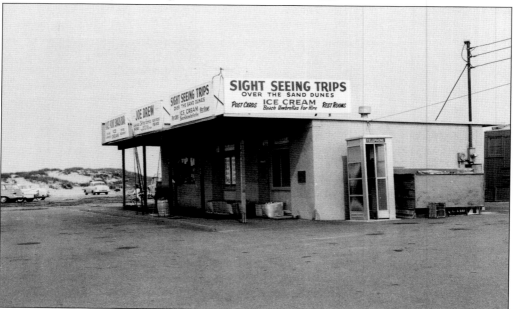

This concession stand at Herring Cove Beach was the property of Massachusetts State Parks before the National Park Service acquired the land. Signs above the vendor window read, "Where the 'elite' meet to eat," "T-Bones 25 cents, With Meat $2.50," "Eat here Diet Home," "Buy something you fools! We didn't install this beach in front of this stand for nothing!" and "Recommended by Drunken Heinz."

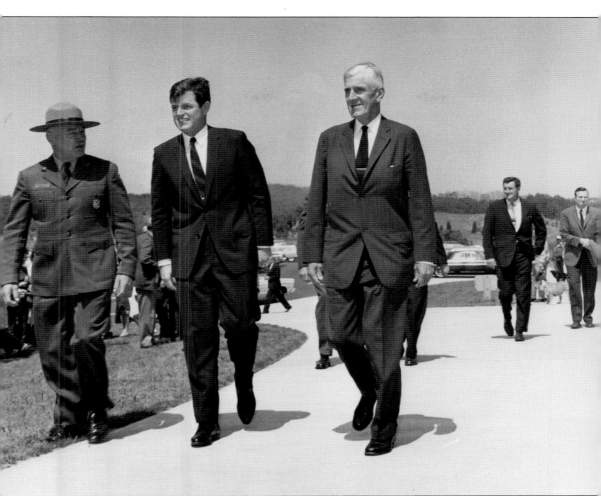

On the second day of the Eastham hearings, Victor F. Adams, chair of the Barnstable Board of Selectmen, said, "I am opposed to this scheme. It is difficult for me to understand why so many Cape Codders who know that the national park would be very bad for Cape Cod have not actually registered vigorous opposition. If . . . Cape Cod is made available to the entire country, its attractions will cease to exist . . . The dunes are no longer attractive when swarms of people are climbing over them." On the opening day of President Kennedy's 87th Congress, January 3, 1961, identical bills to establish the seashore were introduced in the House by Representatives Boland, Lane, and Keith. A few weeks later, Representatives F. Bradford Morse and Silvio O. Conte followed with two more bills. On February 9, 1961, Senators Saltonstall and Smith cosponsored a bill as successor to the Kennedy-Saltonstall bill of the previous June. Such struggles made the celebrations that came years later seem unlikely. The photograph shows Supt. Stanley C. Joseph (left), Sen. Ted Kennedy (center), and Leverett Saltonstall (right) at the seashore dedication in 1966.

With competing bills in the House and Senate, the process stalled. Both the House and Senate announced hearings on the issues. Cape Cod's congressman Harrison Keith spoke in favor of the park but leaned toward more compromise. He was, for example, in favor of leaving the Fort Hill area in Eastham out of the park. Secretary of the Interior Stewart Udall spoke, referring to President Kennedy's past efforts in the Senate and his continued support.

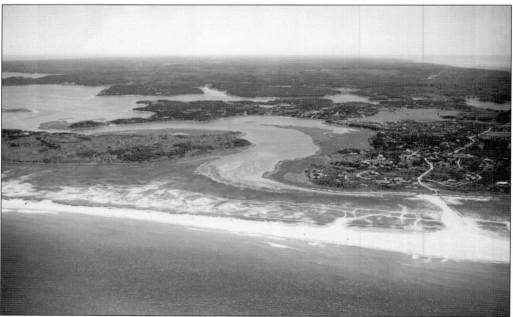

On March 21, 1961, two weeks after the House and Senate hearings, Congressman Keith introduced a revised draft of his bill, with amendments and boundary changes the towns wanted, including revisions to the Nauset area, seen here. But boundary differences between the House and Senate bills made it impossible to continue.

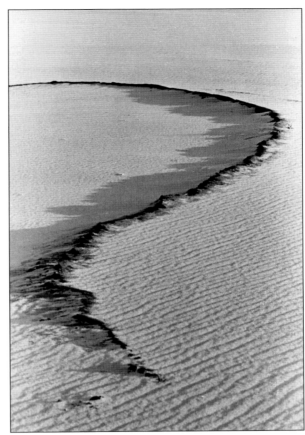

By April 1961, it was clear that the only way to break the logjam was for everyone involved to fly over, drive through, or walk around Cape Cod and see it for themselves. In late April, the following federal, state, and local representatives assembled on Cape Cod to view the disputed land: Senators Alan Bible, Gordan Allott, and Hiram Fong; Sen. Benjamin Smith of Massachusetts; Rep. Hastings Keith; Jonathan Moore and Milton Gwirtzman, both legislative assistants to Massachusetts senators; regional director Ronald F. Lee; and representatives from each of the six affected Cape Cod towns. Striking scenes, like these from the Province Lands, helped change minds.

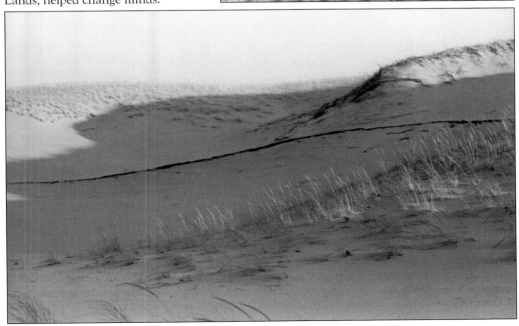

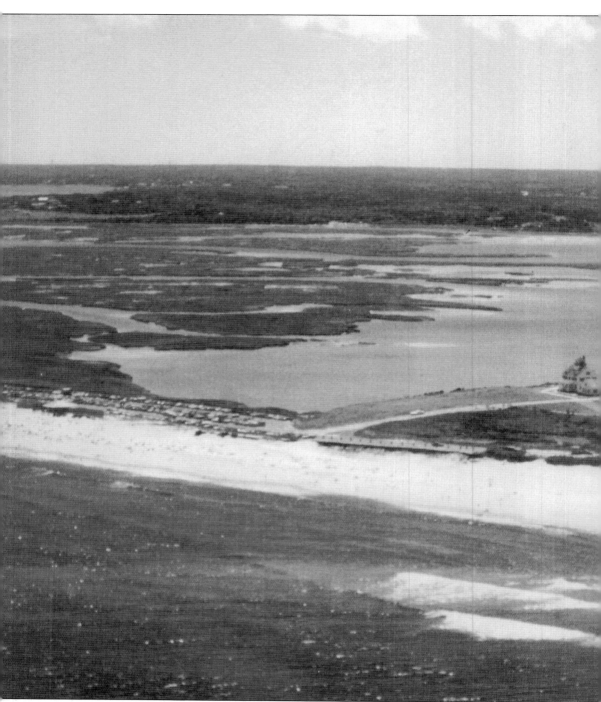

Of the pivotal helicopter flyover, Senator Saltonstall's assistant Jonathan Moore said, "It was a glorious trip. We flew low over Nauset Marsh [seen here] and landed at one point on Fort Hill, and we were standing there, arguing about whether Fort Hill should be in the park or out of the park. It was still up for grabs. A subdivision had been laid out, and there were even some stakes

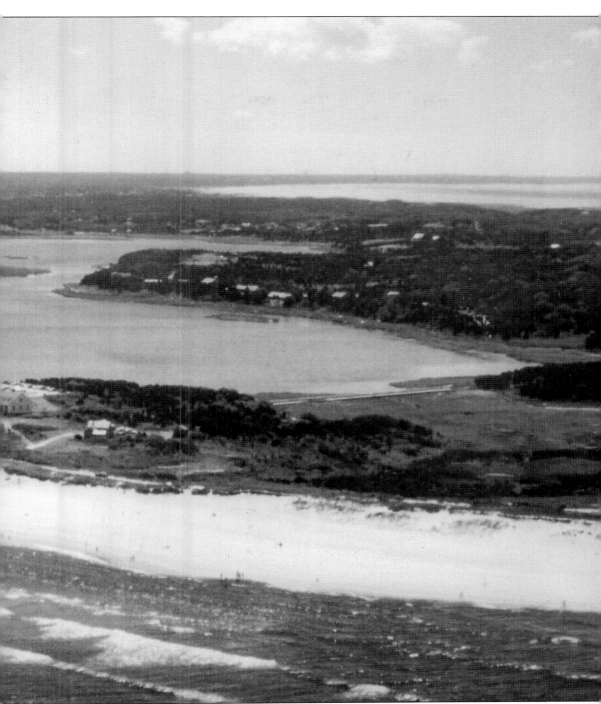

outlining a couple of homes. Keith was still trying to keep Fort Hill outside the boundaries, but later Senator Bible leaned over in the helicopter and said to me, 'That decided it for me!' We didn't give in. You get to the point where if you start to let up or loosen up, the whole thing could go. You could compromise yourself into oblivion." (Courtesy of Jack Farley.)

The most far-reaching, visionary change to Cape Cod in the 20th century was about to reach fruition. On June 27, 1961, the Senate took up the Saltonstall-Smith bill. With the help of Hubert Humphrey of Minnesota, the bill passed unanimously. On July 10, the House version of the bill came up for vote. Five Massachusetts congressmen spoke in strong support. The bill passed the House with a vote of 278 to 82. The fragile Pamet-Ballston Beach area in Truro, shown here, would be placed under national protection.

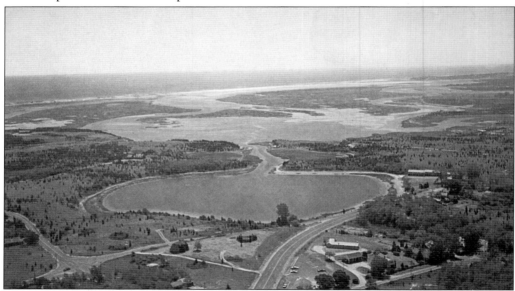

The Berkshire Eagle of Pittsfield, Massachusetts, editorialized on August 3, 1961: "A great public project that seemed almost hopelessly visionary when first proposed five years ago became a reality in Washington yesterday . . . Congress gave final approval to the bill establishing a 26,666-acre national park on the outer shore of Cape Cod." Salt Pond, above, is featured among those acres. "The bill," the paper concluded, "can probably be labeled the finest victory ever recorded for the cause of conservation in New England."

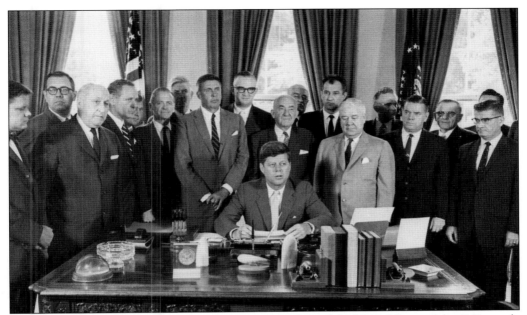

On August 7, 1961, seven months after becoming president of the United States, John F. Kennedy signed the bill creating Cape Cod National Seashore. "This act makes it possible," he said, "for the people of the United States through their government to acquire and preserve the natural and historic values of a portion of Cape Cod for the inspiration and enjoyment of people all over the United States." (Courtesy of United Press International.)

"I join the Congress," said Kennedy, "and hope that this will be one of a whole series of great seashore parks which will be for the use and benefit of all of our people." The CCNS was indeed so successful that this "Cape Cod Model" became a template for other national parks. Of this special place, President Kennedy observed, "I always come back to the Cape and walk the beach when I have a tough decision to make. I can think and be alone."

When most Cape Codders first heard of the national seashore proposal in the 1950s, Jerry Burke had written in the *Yarmouth Register*, "In our shrinking, defiled, and exploited continent we must hold on to the few remaining miles of unspoiled beaches. Whose side are you on, God's or man's? The Creator's or the destroyer's? Is this a difficult choice to make? We must not diminish the Great Outer Beach by the length of one gull's wing or the shadow of one beach plum. Let America come here and replenish its soul." In the 19th century, Thoreau said that visitors to the Cape looking for "merely a ten-pin alley, or a circular railway, or an ocean of mint-julep," or thinking "more of the wine than the brine" would be disappointed. Cape Cod National Seashore has kept his words true and assured that, as Thoreau concluded, "A man may stand there and put all America behind him."

Six

THE EARLY YEARS OF CAPE COD NATIONAL SEASHORE

Of Cape Cod's Great Beach, Henry Thoreau wrote, "They commonly celebrate those beaches only which have a hotel on them. But I wished to see that seashore where the ocean is landlord as well as sea-lord and comes ashore without a wharf for landing." Thoreau's wish became reality with Cape Cod National Seashore. But when President Kennedy signed the legislation in 1961, there was little time to celebrate. The great work was just beginning.

On April 8, 1962, Robert F. Gibbs became the first superintendent of Cape Cod National Seashore, after having been superintendent of the Cape Hatteras National Seashore. Despite some initial resistance (Gibbs moved his family to a rented house only to find a sign by the owner forbidding his occupancy), Gibbs said Cape Cod was the "friendliest place" he had ever seen. He is seen here meeting with First Chief Ranger Van der Lippe in front of Nauset Light.

It would be five years from the beginning of the seashore to the great day of its formal dedication in 1966. Meanwhile, there were 3,600 parcels of land to be transferred, construction of visitor centers and offices, and the staffing of the park with rangers, lifeguards, and other workers. This photograph from around 1963 shows the first information booth, just west of Orleans rotary on Highway 6.

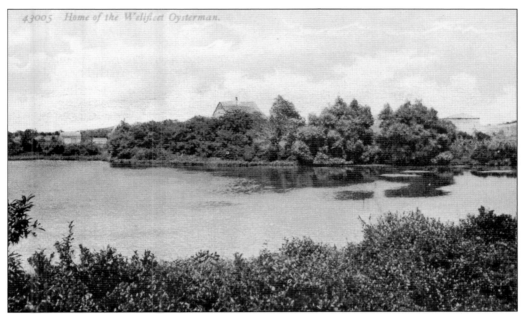

There were about 660 homes and 19 businesses, including gas stations, restaurants, campgrounds, cottage colonies, and golf courses within the new park boundaries. Each came with questions—would homeowners sell to the park? Stay and abide by restrictions? What of motels? Which town-owned parks and beaches would be transferred to the national seashore? The Wellfleet oysterman's house, above, visited by Thoreau in the 19th century is now within CCNS.

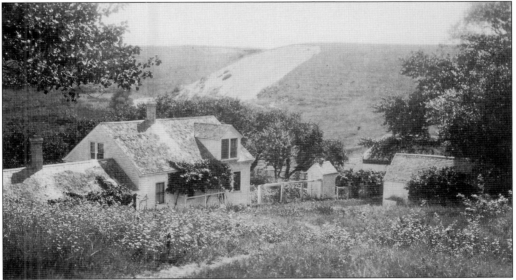

Unique to the park were the agreements available to homeowners within its borders. Homes built before September 1, 1959, could remain. Property with homes built after that date could be taken for public use. Sensitive to landowner apprehension, the national seashore used a spectrum of acquisition techniques, including purchase, occupancy or life tenancy, and of course, gift. The Warren Small farm at Pilgrim Heights, Truro, for example, was given to the seashore by Roger Hagen.

Owners who agreed to sell were given four options: outright sale, sale with the owner retaining life-tenure rights, sale with the owner retaining tenure rights for a fixed period (up to 25 years), or sale of unimproved lands with retention of home site ownership in perpetuity (in which case the national seashore's right of condemnation was suspended.) George Higgins retained a life tenancy upon transfer of the Atwood-Higgins House in Wellfleet to the Department of the Interior.

By 1968, the original $16 million allowed for property acquisition was exhausted. With rising costs, even the additional $17.5 million allocated in 1971 was not enough. Those owners who had not sold to the seashore, such as the owner of property like Bearberry Hill in Truro, above, were allowed to stay but were required to abide by national seashore guidelines for development. The National Park Service, however, had little authority to enforce the guidelines.

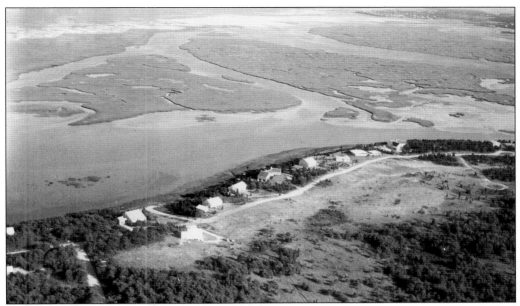

To give legal authority to the national seashore development guidelines, towns were encouraged to adopt the guidelines into their zoning bylaws. Yet the town of Eastham was the only town to have done so. The photograph shows development coexisting with the national seashore in Eastham. The redevelopment possibilities of Seashore properties in other towns were open to interpretation.

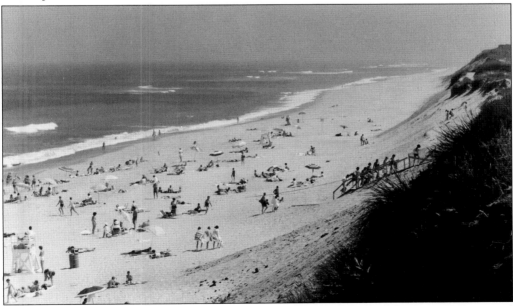

The Province Lands in Provincetown and Pilgrim Springs State Park in Truro were conveyed to the United States in 1962. The title to the Province Lands provided that a portion would be subject to a pre-existing lease for the Provincetown Airport. Coast Guard Beach and Nauset Light Beach in Eastham (above) were deeded by the town to the United States in 1963 and 1965, respectively. In return Eastham taxpayers were given free access.

The former site of the Marconi Wireless Station in South Wellfleet became Camp Wellfleet in 1943. It was the antiaircraft artillery training center for Camp Edwards on the Upper Cape. Men were sent from Camp Edwards to train on the firing range of Camp Wellfleet. With the creation of Cape Cod National Seashore, the U.S. Army transferred title in 1961. (Courtesy of William Quinn.)

Camp Wellfleet contained 17 single-story barracks that housed 50 men each. There were four company administration and supply buildings, five lavatory buildings, an assembly hall that held 400, an infirmary, a post exchange, ammunition magazine, storehouse, and firefighting unit. The Job Corps arrived in 1964 to remove buildings. (Courtesy of William Quinn.)

The demolition of Camp Wellfleet required the cleanup of many hazards, including thousands of spent shell casings. Certain features would remain as the land was prepared for the construction of the new national seashore headquarters. In fact, a helicopter pad is still visible behind the headquarter buildings.

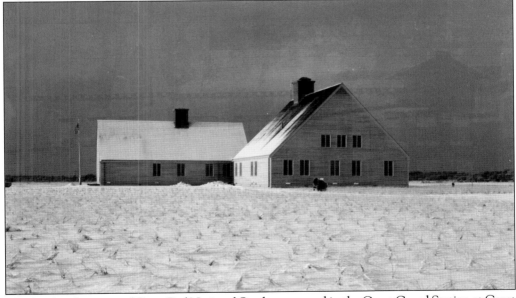

The first headquarters of Cape Cod National Seashore opened in the Coast Guard Station at Coast Guard Beach, Eastham, in 1961. Currently that building houses Cape Cod National Seashore's overnight National Environmental Educational Development (NEED) program for school groups. The park's present administrative headquarters (above) was built near the Marconi Station site in 1965, on land that had been part of Camp Wellfleet.

To create a uniform architectural look for National Park Service buildings, the advisory commission sent letters to 12 leading American architects, among them Walter Gropius. The commission was encouraged to combine the best of contemporary and traditional styles. In 1965, the Salt Pond Visitor Center was opened, with panoramic views of Salt Pond and separate museum and auditorium wings. It was controversial at the time, with some people referring to it as "that beehive thing."

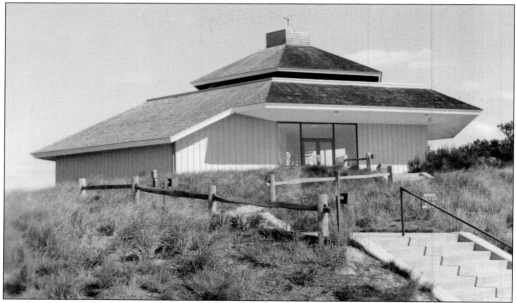

Stanley C. Joseph followed Robert Gibbs as superintendent on January 30, 1966. By then the success of the national seashore was evident—there was traffic congestion, a shortage of parking, and heavy use of the limited bike trails. Land acquisition funds were nearly gone. That year, a second visitor center in the Province Lands was proposed, reviving the previous debate over architectural style. Termed the "Chinese pagoda," it was dedicated on May 25, 1969.

Kurt Vonnegut Jr., a 15-year resident of the Cape, wrote, "After some of the most amusing wrangling in the history of the National Park Service, Cape Cod National Seashore Park is a reality . . . one of the smallest national parks, and one of the most queerly shaped." He quoted opponent Chester Crocker of Marston Mills: "Most all of the outer beach in the area is dangerous and unfit for swimming by the public." Vonnegut countered, "He had a point . . . A frolic in the big rollers of the open Atlantic can be like playing middle linebacker against the Cleveland Browns. And the water is frequently so cold . . . that a quick dip can be like falling overboard on the run to Murmansk. Only children seem able to stand such punishment for long. They can stand it all day." Vonnegut appreciated getting information about "birds and erosion and fish and bayberries," but enjoyed more seeing visitors "whoop and holler . . . gasp and sputter and laugh as the waves slam them silly . . . [they] fish without a worry in the world . . . [they] walk for miles, and . . . walk alone."

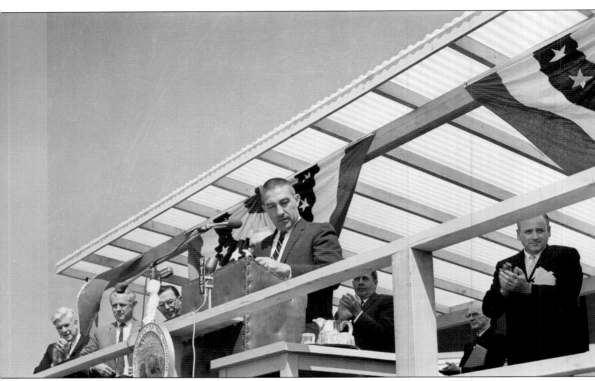

On Memorial Day weekend in 1966, Cape Cod National Seashore Park was dedicated. The front-page story in that day's *New York Times* announced, "The first land the Pilgrims sighted before landing at Plymouth 346 years ago was dedicated today as Cape Cod National Seashore . . . The dedicatory exercises were held on the lawn outside the newly dedicated visitors' center . . . situated on a knoll overlooking Salt Pond and beyond to Nauset Bay . . . Secretary of the Interior Stewart L. Udall [pictured above] declared: 'We who have chopped and mined and built and machined our way to wealth and power now grope out from our cities, puzzled, yearning, almost wistful, for something we cannot forget. Beyond the noise and asphalt and ugly architecture we yearn for the long waves and beach grass; we see white wings on morning air, and, in the afternoon, the shadows cast by the doorways of history."

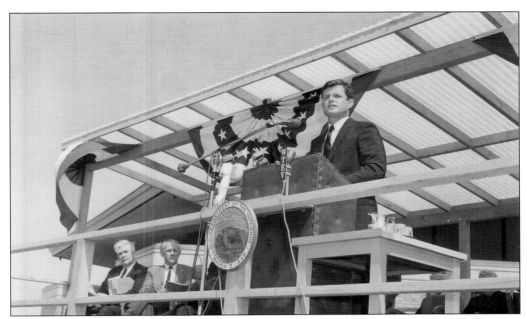

Sen. Edward Kennedy is seen here introducing Sec. Stewart Udall at the CCNS dedication. Also taking part were Sen. Leverett Saltonstall and Rep. Hastings Keith, both Massachusetts Republicans, who cosponsored one version of the park bill. Luther Smith, chair of the Eastham Selectmen, spoke for the selectmen of the six towns in the park.

At the dedication, Udall joined other speakers in tributes to President Kennedy, pictured here signing the legislation that created CCNS on August, 7, 1961. It was part of Kennedy's philosophy, Secretary Udall said, "that a father should be able to show his children—all children—the wonders of nature he himself had known. The marshes, the seascapes, the sea itself should remain inviolate for all time for all men."

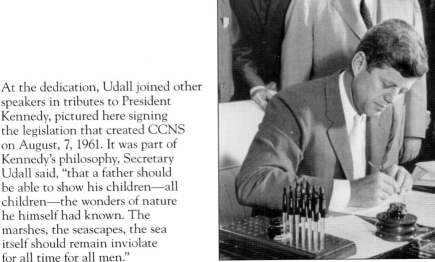

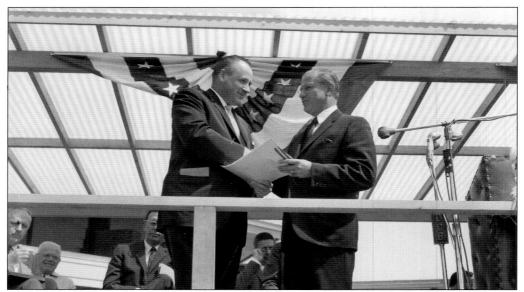

Gov. John A. Volpe (right) presented the deeds of the Province Lands Reservation to George B. Hartzog Jr., director of the National Park Service. This protected the Province Lands forever, a place known as the second-oldest common lands in the nation, second only to Boston Common. About 2,000 people attended the ceremonies.

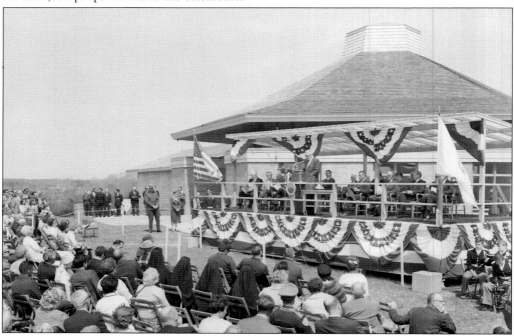

Much of what Henry Thoreau cherished about the Outer Cape 100 years before the dedication of the seashore is still in evidence within the vastness of the park. Thoreau wrote, "Though once there were more whales cast up here, I think that it was never more wild than now. We do not associate the idea of antiquity with the ocean, nor wonder how it looked a thousand years ago, as we do of the land, for it was equally wild and unfathomable always."

Seven

BEACHES AND LIFEGUARDS

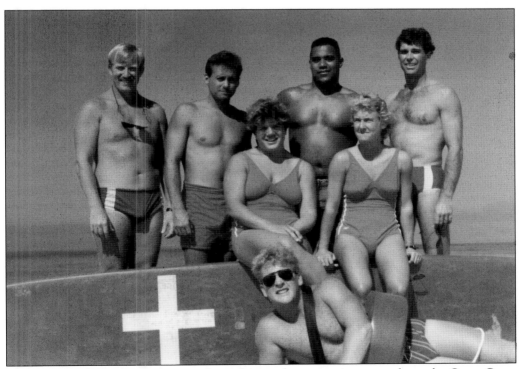

In the 1800s, there was an average of two shipwrecks every winter month on the Outer Cape. The U.S. Life Saving Service rescued nearly 179,000 people before becoming part of the U.S. Coast Guard in 1915. As the age of the sail waned, so did the number of shipwrecks. A new type of modern lifeguard emerged. This team from 1985 includes, from left to right, (first row) Tom Hayden; (second row) Caroline Freitas and Cindy Piela; (third row) Jack Farley, Dan Rahill, Gordan Miller, and Dave Murray. (Courtesy of Jack Farley.)

The lifeguards of Cape Cod National Seashore cover the six federally protected beaches that stretch from Eastham to Provincetown. The hazards of open water beaches vary dramatically from place to place. Crowd conditions, water currents, dangerous wildlife, and ocean weather contribute to an average of 350 rescues and assists per year by the seashore's highly trained lifeguards. Pictured here is Irving Tubbs, North District head ranger, in 1984. (Courtesy of Jack Farley.)

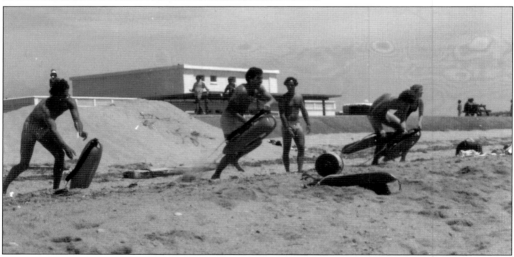

These lifeguards training at Herring Cove Beach in Provincetown stick to a strict regimen. The CCNS lifeguard handbook from 1963 states, "Before Lifeguards report for duty . . . they must successfully complete a Surf Rescue School . . . Lifeguards demonstrate ability in swimming skills, handling of torpedo buoy and paddleboards, life saving skills, first aid, and resuscitation. The early June water, which is in the low 50s, tests the endurance of all the Lifeguards." (Courtesy of Jack Farley.)

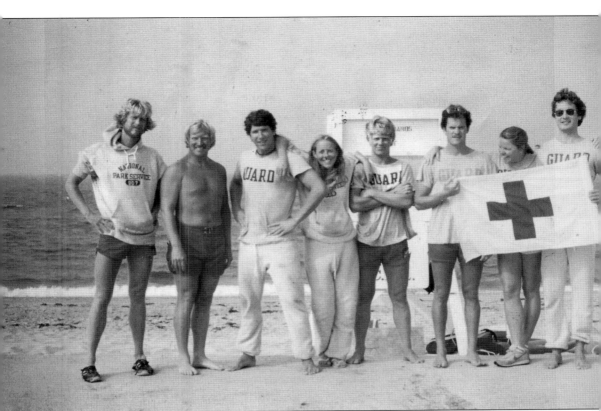

It is often said that lifeguards are heroes. Those at the Cape Cod National Seashore have proven this many times. Jack Farley (second from left), who for decades oversaw the lifeguards at Head of the Meadow Beach, noted that 15–20 assists a day were normal for the Fourth of July weekend and that a life has never been lost on a protected CCNS beach. Pictured from left to right are Scott Leonard, Farley, Tom McGuinness, Liz Angus, Steve Stoner, Bob Gomez, Lise Hembrough, and Rich Chmielinski. Tom McGuinness was a hero twice over. He became a top pilot flying F-14s for the navy, then flew for American Airlines. Three days after his 42nd birthday, on September 11, 2001, Tom was copilot of American Airlines Flight 11 taking off from Boston. When the plane was hijacked by terrorists and flown into the World Trade Center, he died along with the pilot, nine flight attendants, and 81 passengers. (Courtesy of Jack Farley.)

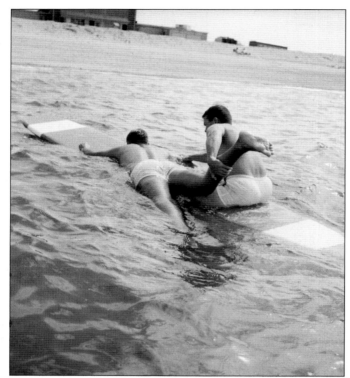

Girls and boys ages 13–16 can train to become junior lifeguards with the National Park Service. They learn how to swim safely in surf and rip currents, ocean rescue techniques, CPR and first aid, and the use of oxygen tanks and automatic external defibrillators. Those aged 15 and older can earn their American Red Cross lifeguard certifications and can become seashore lifeguards. Here an early rescue technique is demonstrated at Herring Cove Beach. (Courtesy of Jack Farley.)

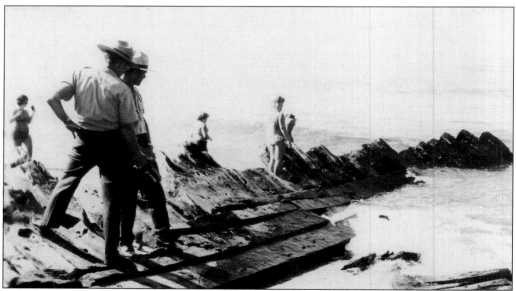

Shipwrecks, like that of the 18th-century, British man-of-war *Somerset*, were once common off of Provincetown. (The wreck surfaced briefly in 1973, as seen above.) Modern vacationers were shocked to see a present-day wreck before their eyes in 1985—that of an aircraft. On August 18, a small airplane went down off Race Point. The case incident record reported: "On 8-18-85 at 10:12 hours, Head Lifeguard Richard Chmielinski . . . made visual contact with a single propeller aircraft, identified through binoculars as Piper Cherokee 6 No. N15805."

When Gerald N. Strom's plane crashed off Race Point in 1985, it remained buoyant only long enough for Strom to exit. According to the lifeguard report, "Strom was actively drowning at this time. A bystander-swimmer . . . Daniel Cummings, swimming per chance only 50 yards from the downed plane, assisted Strom to shore. Lifeguard John Madigan entered the water and assisted Strom into shore using a single armpit assist . . . Strom appeared to be in shock, exhibited a slight laceration on his forehead . . . Strom stated to Madigan that he was alone in the aircraft. Lifeguard Madigan relinquished control of Strom to Lifeguard Daniella Infield. LG Infield administered first aid to Strom, applied oxygen via inhalator mask, and monitored vital signs. Within minutes the Provincetown Rescue Squad arrived and continued medical services to Strom." This photograph at Herring Cove Beach demonstrates techniques used to save the downed pilot. (Courtesy of Jack Farley.)

During the dramatic rescue of pilot Gerald Strom in 1985, lifeguard John Madigan assisted Strom into shore (much like this photograph of a rescue drill at Herring Cove Beach). Lifeguard Rich Chmielinski swam out 50 yards to the aircraft through a gasoline slick without knowing if others were trapped underwater. Chmielinski dove down 6 feet and after several attempts located and opened the rear pilot side door of the plane. External water pressure shut the hatch door, briefly trapping Chmielinski inside. (Courtesy of Jack Farley.)

Lifeguards like these never know when they will be tested. After pilot Gerald Strom's plane went down in 1985, lifeguard Chmielinski searched the underwater aircraft for survivors. Held by the ankles, he searched the craft four times, finding it empty. Head District lifeguard Jack Farley then swam out to the aircraft. He made an additional search of it then cleared several small boats away from the dangers of the spilled gasoline. (Courtesy of Jack Farley.)

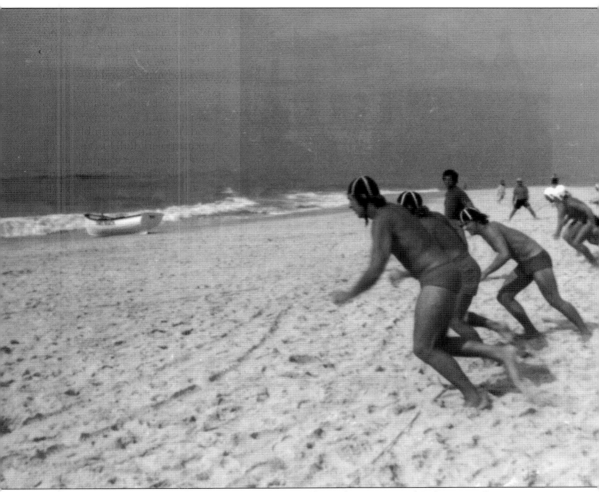

Each summer, lifeguards polish and test their skills at the Cape Cod Lifesaving Competition, as seen in this photograph on Long Island in 1971. Of the 34th annual competition in August 2008, the *Cape Cod Times* reported, "Competition began with the loud echo of a bullhorn and eager cheers from the crowd at West Dennis Beach. Colorful tents and energetic fans marked the different locations of the 11 teams. Erin McLaughlin, 20, a lifeguard at Cape Cod National Seashore, said, 'We trained all summer with one-hour workouts every day in either swimming, running, or paddling.'" This type of training proved critical in the aftermath of the Race Point airplane crash of 1985. Lifeguards Jack Farley and Rich Chmielinsksi assisted park rangers in extrication and salvage of the aircraft by swimming winch lines from shore and attaching them. Chmielinski retrieved the floating flight bag and various aircraft parts. Lifeguard Kate FitzGerald assisted in crowd control and radio communications. The smooth, highly professional response by CCNS lifeguards and rangers that day prevented what might have been a disaster with multiple fatalities. (Courtesy of Jack Farley.)

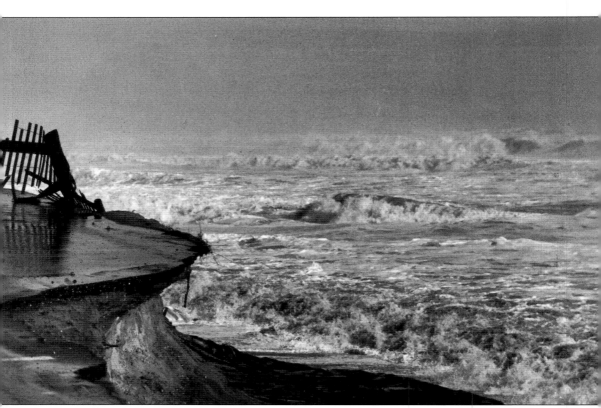

Weather forecasting was relatively primitive when the notorious storm of 1978 struck, as seen above. Today lifeguards at the national seashore are aided by the SKYWARN system. The National Weather Service trains local Cape Codders as storm spotters, who report local wind gusts, hail size, rainfall, and cloud formations that could signal a developing tornado. Bob Grant, chief ranger at Cape Cod National Seashore, says, "Early access to information about approaching severe weather is extremely valuable to our operation. Having information that a dangerous storm is going to impact one or several of our beaches, allows our lifeguards and rangers to take precautions and maybe even evacuate an area where thousands of unprotected beach users may be located. Everyone's safety is greatly enhanced by these warnings." SKYWARN is a concept developed in the early 1970s to promote a cooperative effort between the National Weather Service and communities.

Eight

RANGERS AND
SPECIALISTS IN THE FIELD

In early 2009, Bob Grant was selected as the chief ranger of Cape Cod National Seashore. Grant served as the seashore's South District ranger working out of the Nauset Ranger Station and before that, as a park ranger at the Race Point Ranger Station. "The men and women in the flat hats," as Grant affectionately calls them, are responsible for the safety of more than four million visitors per year.

Chief ranger Bob Grant traces the origins of his rangers back to the U.S. Cavalry, sent into Yellowstone Park to protect the land from poachers of animals, minerals, and timber. The rangers and specialists of Cape Cod National Seashore are a dedicated team, highly trained to conserve and protect Cape Cod National Seashore. (Photograph by Jack Finley.)

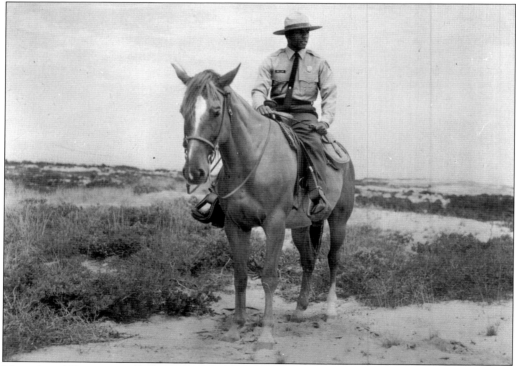

More than 130 years ago, Yellowstone became the first national park. By 1916, some 35 other parks and monuments had been set aside, leading Congress to create the National Park Service. In the 1960s, two trained horses from Yosemite were donated to CCNS, initiating the national seashore horse patrol (no longer active). Park ranger Robert Tignor is seen here in 1966. The horses adapted easily for patrol along the beaches and in remote areas closed to vehicle access.

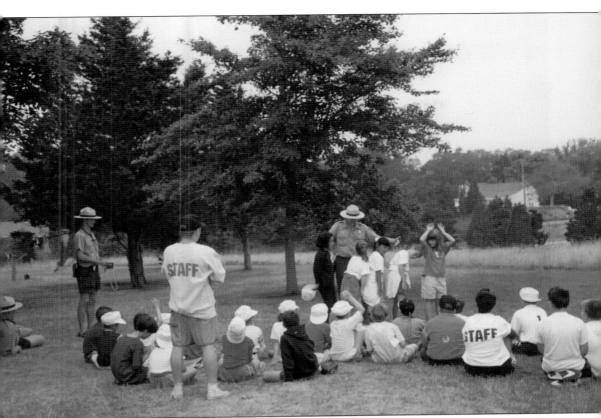

Chief Ranger Grant began his career with the National Park Service in 1976 at Great Smoky Mountains National Park in North Carolina and Tennessee as an interpretive ranger and a backcountry ranger for three summers. After graduating from college, Bob was hired as a year-round ranger, park medic, and supervisory park ranger. He developed a strong background in several operations, including law enforcement, EMS, search and rescue, wildland fire, backcountry, and bear management. Except for bear management, each of Bob's skills is utilized at the seashore. He says that along with the millions who visit the park each year come the social problems of their home environment. This photograph shows rangers leading a drug education program in 1993. Most park rangers are trained in law enforcement, hunting and game law, fire protection, and as medics and EMTs. They work closely with the law and safety agencies of the surrounding Cape Cod towns. Thus Bob reports that the crime rate within the national seashore is "staggeringly low."

The park rangers, environmentalists, natural resources management staff, and other specialists have a dual function: to protect the Cape's natural environment, and to protect the people who enjoy it. Thus when 700 gray seals began spending summers in 2006 at Head of the Meadow in Truro, Chief Ranger Bob Grant, above, saw to it that the seals were protected from visitors and visitors were protected from the seals.

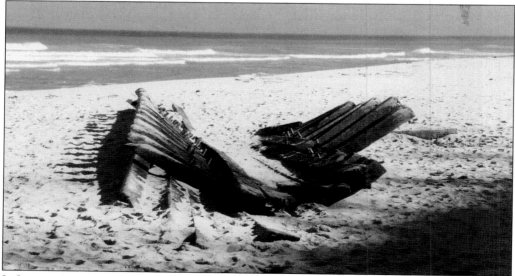

In January 2008, a storm washed up a 60-foot section of a wooden shipwreck at Newcomb Hollow Beach in Wellfleet. Built in the 1800s, this type of vessel transported goods along the New England coast and beyond. National park rangers welcomed visitors to educational talks at the site. One of the seashore's greatest assets, according to Chief Ranger Grant, is a public who enjoys seeing shipwrecks and seals and becomes invested in the welfare of the park.

Ecologist John Portnoy was one of the park's many specialists. Among his many projects, he built this osprey nesting platform on Great Island in Wellfleet in 1980. Portnoy, who was with the seashore from 1979 to 2008, says, "I think that the seashore as a management agency has gotten better at achieving its mission of preservation and sustainable public use over the 30 years of my tenure. Improvement has paralleled the increase in ecological theory and scientific literacy among politicians, park managers, and the public (not always in that order). Also, I think that NPS managers have gotten more proactive and bolder in protecting and restoring natural resources, and much more enthusiastic about working cooperatively with the 'Seashore Towns.' It's much more accepted today that NPS can't protect park resources at a place like CCNS without paying close attention to, and keeping involved in, what happens outside the park boundaries."

The rangers and other experts at the national seashore offer an extraordinary number of activities for every variety of visitors. For example, Dan Meharg and Hortense Kelly led a Christmas program at the Penniman House in 1993. There are programs about life on Cape Cod in the 1800s; historical lifesaving methods using signal flags, Morse code, and lighthouse signals; and historical operations of the Old Harbor Life Saving Station. There are canoe and kayak trips; programs on the botany of dunes, tidal restoration, oyster habitats, native life on the Cape, food- and candle-making at the 1700s Atwood Higgins House; and programs on shipboard activities, whaling, and scrimshaw at the Penniman House, to name just a few.

For 24 years, Mike Whatley was an essential part of the national seashore team. He served as park historian for 15 years, and as district interpretive supervisor, then branch chief for public information. He recalls that, "The Penniman House was boarded up when I first came on duty in 1977; our crew got permission to open it up. It is now an active, fun place to visit. We got the Three Sisters [lighthouses] opened up too."

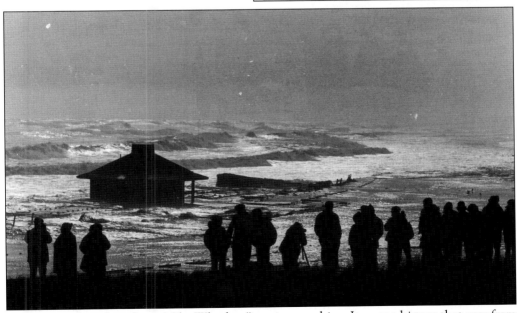

"The national seashore," says Mike Whatley, "is a time machine. It saves a history that goes from prehistoric Native Americans, to European explorers, to the Mayflower passengers, to Lighthouses and Lifesavers, to Thoreau, to Marconi and wireless. And it is an equally impressive natural treasure trove. The old Coast Guard Station in Eastham is a great vantage point, and witnessing the Great Storm of 1978 [seen above] was simply amazing."

The National Park Service is committed to helping young people understand the special qualities of the national seashore and the importance of developing a stewardship ethic for its future. The seashore's junior ranger program is for kids between the ages of 5 and 12 and takes at least two days to complete. Junior rangers join park rangers like Katie Finch (above) to look for seals, tour historic lighthouses, and learn the natural history of the seashore.

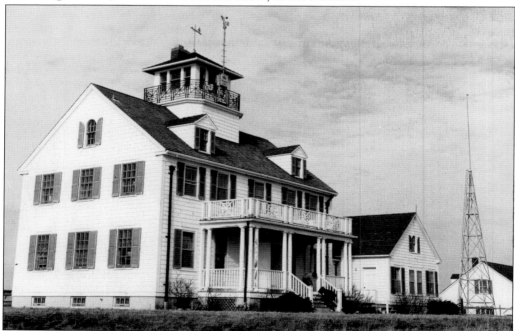

The seashore's residential environmental education program (NEED) offers educational groups an opportunity to experience the natural and historical wonders of Cape Cod. Groups come from a wide range of areas, some as far away as Ohio, Colorado, and Virginia. Groups with special-needs clients or from inner city environments are encouraged to participate. The program, led by education coordinator Barbara Dougan, is housed in the former U.S. Coast Guard station at Coast Guard Beach (above).

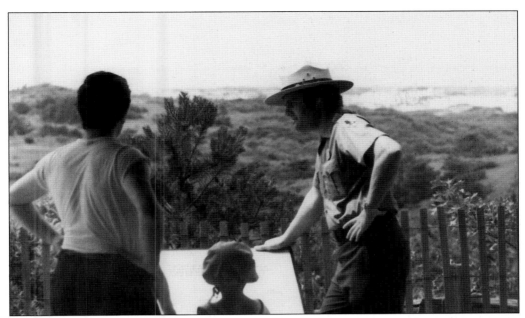

David Spang has the extraordinary distinction of having been a ranger at the park since 1963, the first year the national seashore was open to the public. He recalls, "The first season, I was sometimes the only uniform on duty on the late season weekends. Not a very large staff at the beginning. The HQ was at the Coast Guard building in Eastham, and a couple of the barracks at Camp Wellfleet were used as indoor facilities during bad weather."

"Many of my favorite memories," says David Spang, "come from the early years sitting in Tommy Gilbert's kitchen putting together the design for the seashore emblem while his wife, Patsy, painted it. [Or] Meeting Henry Beston when he came back to the Cape for the first time since writing *The Outermost House* in order to turn over ownership to Wellfleet Audubon." Pictured is the first CCNS staff, with Supt. Robert F. Gibbs third from left.

David Spang recalls helping scientists probe Nauset Marsh to age date salt marsh peat, and matching Champlain's map to the present only after thinking to correct for the drift of the North Pole. He particularly enjoyed finding a boulder to represent the erratics left after glacial retreat. It came from Nauset Heights and is still at the visitors center. The best example, Doane Rock (pictured above), was much too large to move.

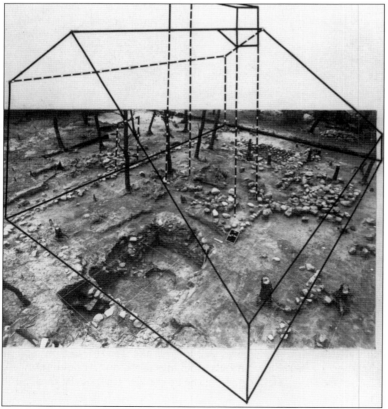

David Spang recollects working with seasonal historian Ralph Linwood Snow for several years. "He and I planned the trail on Great Island in Wellfleet and [viewed] the site of the original Smith's tavern." Here is an outline of Smith's Tavern superimposed over the site after a dig by archeologists from Plimoth Plantation. Spang and Snow developed the original trail in Fresh Brook Village where Snow's ancestors had settled.

David Spang spent all of his teaching breaks in the winter of 1963–1964 on his hands and knees cutting through the Bear Oak forest at White Cedar Swamp, above, to create the trail. "One of the trunks," he says, "was only a couple of inches across. It measured out at about 75 years of age and had been part of the Lilliputian forest of Thoreau's walk."

David Spang, pictured at right in the first row, recalls, "The first female ranger in the park service was Melinda Melby. At first they [female rangers] looked like stewardesses on a plane. The requirements of a skirt, short heeled shoes, and silk stockings just didn't work out on walks in the dunes and woods . . . someone finally came up with the bright idea that maybe they should be dressed like all the other rangers."

Early park ranger David Spang tells of the opening of the Province Lands bike trail in the 1960s, the first in a national park: "I saw Dr. Paul Dudley White, Eisenhower's physician, finish before anyone else, even though he was in his 70s. He was one of the early promoters of bike riding for good health."

David Spang said, "I started seasonal time on the Cape in 1939, before any real development had occurred. Most of the roads were still unpaved—electricity hadn't arrived in my part of Mashpee. CCNS has meant a way for me to raise my family with access to the sea and sand that I had in my youth. My four children have that special feeling about the Cape that my wife and I have, and are now bringing their kids here as often as they can."

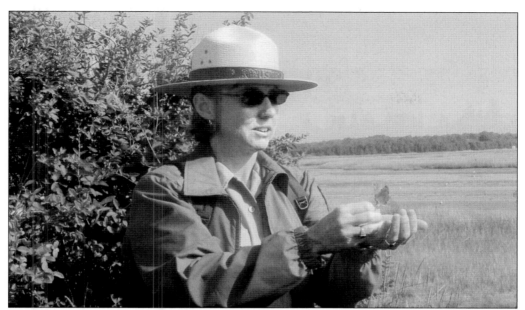

Suzanne Haley, South District interpreter, has been with Cape Cod National Seashore since October 1990. CCNS is, she says, "the place where one can find solitude and serenity . . . or be thrilled by the forces of nature." Sue recalls arranging holiday celebrations at the Atwood Higgins and Penniman houses for 10 years. "[They were] all-hands event for the interpretive staff and volunteers."

Sue Haley's fondest memory is "getting kissed on the cheek by Princess Elettra Marconi (Gugliemo's daughter) on Marconi Day, 2003." Princess Elettra is on the far right next to Sue Haley. Sue's oddest memory is of policemen surrounding her while she hovered over a dolphin carcass with a butcher knife behind a shed as she collected a bone specimen. The police were trying to determine whether she was working on a marine mammal or a mammal of the two-legged variety.

Jenna Sammartino has been with CCNS since 2004: "One memory that stands out for me occurred my first or second winter at the park. A commercial fishing boat had wrecked off Coast Guard Beach and reports were that one of the crew was missing. The Cape fishing community is pretty tight-knit, and soon my husband and I were among several others scanning up and down the beach for the missing man. Our law enforcement staff was on the beach, the local harbormasters were on the water, and the Coast Guard helicopter kept doing flyovers. It was freezing cold, we were out there for what seemed like hours, and I remember my husband saying, 'If it was me out there, I'd want to know no one was going to give up until I was found.' So we kept our binoculars trained on the waves . . . Being at Coast Guard Beach, with the old white Coast Guard building in the background, I couldn't help but think about the days when men from the U.S. Life Saving Service patrolled the beach and this kind of thing happened all the time."

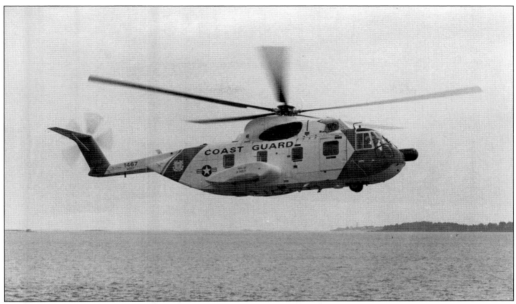

Jenna Sammaratino recalls seeing a fishing boat wreck a few years ago off Coast Guard Beach. She noticed the Coast Guard helicopter had stopped searching. It turned out, she says, that "the fisherman was alive and well, but the circumstances were the best part of it. Someone walking past the Coast Guard building had noticed that one of the basement windows was broken. The missing man had swum to the beach and then made his way to the building, where he broke in, took a hot shower and fell asleep! I just thought it was so amazing that all these years later, that old building was still doing exactly what it had been built to do—save the lives of shipwreck victims." (Below, courtesy of William Quinn.)

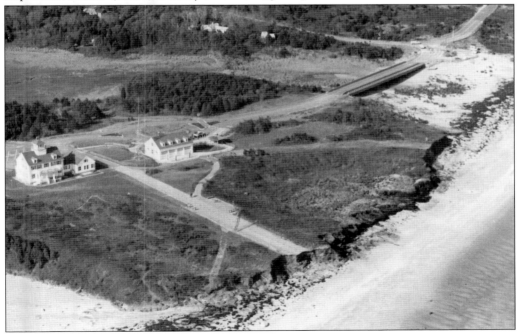

When Bill Burke (left) began as a seasonal ranger in 1984, his first reaction was, "You've got to be kidding me—this place is drop-dead gorgeous. This is a dream job." Early on Burke led breeches buoy Life Service demonstrations. Since 2000, he has been park historian and cultural resources program manager, responsible for 76 historic structures, 250 archeology sites, 500,000 museum objects, and major cultural landscapes like Fort Hill.

"Having seen and worked in several parks," Bill Burke says, "this one is special because it's relatively small, intimate and fun . . . it is still easy, despite the summer crowds, to find your private place. I take what residents say very seriously and am humbled to be one of the 'holders' of that local heritage." Here Bill takes part in the installation of a mid-19th century hay barge at the visitors center.

Nine

GROWING POPULARITY AND GROWING PAINS

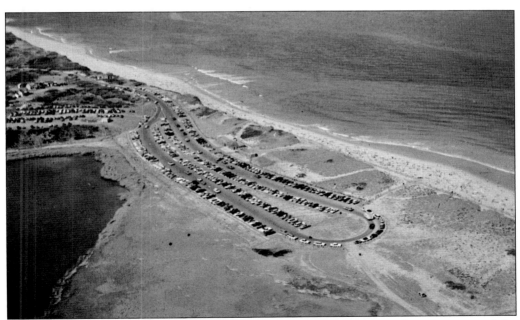

By nearly every measure, Cape Cod National Seashore is a great success. It ranks as one of the 10 most visited national parks. By the 1970s, parking lots, like this early lot on Coast Guard Beach, were overflowing. Park historian William Burke notes, "The park continues to weather growing pains related to off-road vehicles, nude sunbathing, local zoning authority, and the dilemma of dune shacks. Severe storms have remodeled the coastline, destroyed beach facilities, and threatened historic lighthouses."

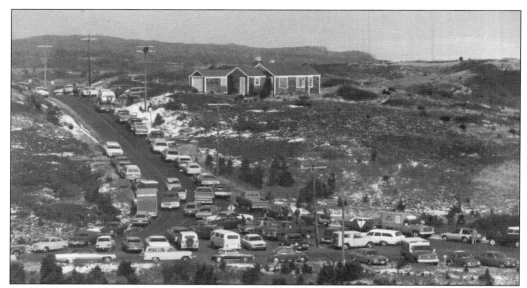

By the 1970s, traffic on Cape Cod had become a serious social and environmental problem, as seen in this photograph of a traffic jam at Coast Guard Beach. Nearly 100 years of Cape Cod vehicle traffic illustrate the growth of traffic. On a single summer day in Sandwich in 1909 there were 57 horse-drawn and 75 motor vehicles; in Sandwich in 1918 there were 23 horse-drawn and 559 motor vehicles. In 1936, Sagamore Bridge experienced 55,000 motor vehicles; in 2005 that number had grown to 130,000.

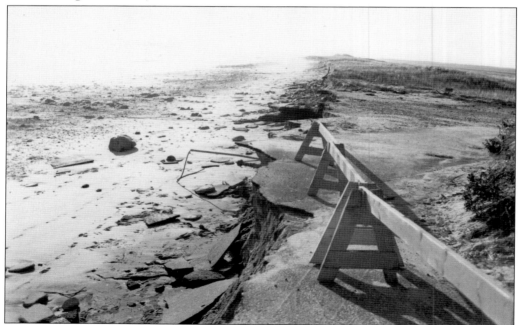

When the Great Storm of 1978 hit Cape Cod, the devastation was extensive. Locally called "the worst storm of the century," it utterly destroyed the 300-car parking lot at Coast Guard Beach (above), which ironically made possible the relocation of the lot to higher ground, away from the fragile shorebird nesting areas of the beach.

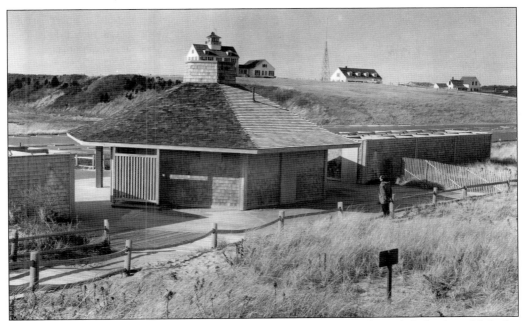

By 1965, shingled, modern bathhouses like this one at Coast Guard Beach helped establish the style of Cape Cod National Seashore architecture. This one lasted only 13 years. On February 6–7, 1978, a tremendous blizzard struck New England with sustained hurricane-force winds of approximately 86 miles per hour and gusts to 111 miles per hour. While a typical nor'easter brings steady precipitation for six to 12 hours, the blizzard of 1978 brought heavy rain and snow for a full 33 hours.

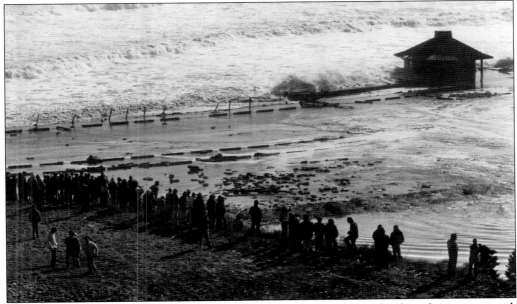

Because the storm developed during a new moon, an unusually large high tide and storm occurred. At Coast Guard Beach, onlookers watched as the Great Storm of 1978 took away the bathhouse. By the time it ended, 100 people were dead in the Northeast and 4,500 injured.

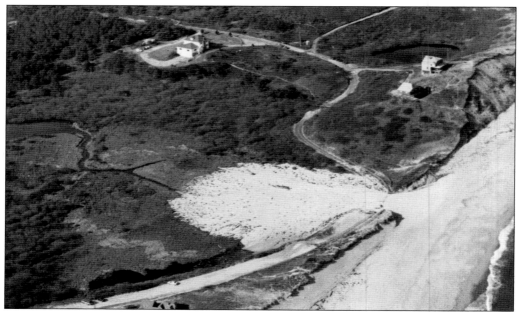

The Atlantic Ocean broke through to the Pamet River at Truro for the first time during the Great Storm of 1978, completely washing away the link between the North and South Pamet Roads. The town chose not to reconstruct the link, though the right-of-way is still open to pedestrians. In 1991, a storm surge, above, again through at the Pamet River. (Courtesy of William Quinn.)

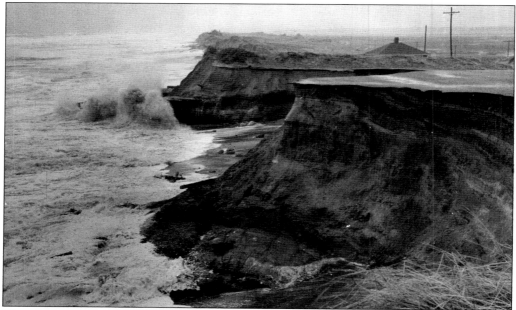

The great writer Kurt Vonnegut noted, "What gives the national seashore such an air of magnificent violence is the fact that the Atlantic is tearing it to pieces." Coast Guard Beach, above, is a good example. "The cliffs have no strength. There are little avalanches all day and all night long. Some of the sand is being carried to Chatham and Provincetown, so that the park is growing at both ends while being chewed in the middle."

Off-road vehicles (ORVs) have been popular at Cape Cod beaches since modified Model T Fords made their appearance. Widespread use of ORVs was not possible until after the advent of the Jeep during World War II. Since then their use has significantly increased. For years, tour vehicles drove through the Provincetown dunes. There was no management of ORV use on the Cape until the establishment of CCNS in 1961.

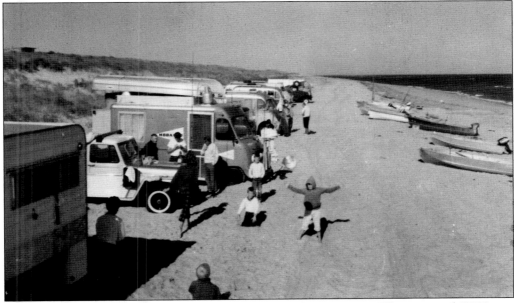

Many kinds of off-road vehicles use the Outer Beach for recreation. The principal ORV user organization, Massachusetts Beach Buggy Association (MBBA), has been effective with self-monitoring. The group established a liaison committee, which provides a link between its members and the park staff. MBBA helps with erosion control projects and extensive beach cleanups, which result in the removal of about 1,500 pounds of refuse each year.

In 1986, the piping plover, a small beach nesting shorebird, was federally listed as a threatened species. The seashore is entrusted to protect threatened and endangered species occurring within the park. As part of the seashore's efforts to protect piping plovers, portions of the existing ORV corridor are closed when piping plover chicks are present.

Roseate terns, listed as a federally endangered species in 1999, are sometimes struck by beach vehicles. These terns use barrier-spit habitats at CCNS for staging. There they rest and feed in shallow waters prior to their southward migration. This occurs primarily in August and September. Spit habitat at the entrance to Hatches Harbor in Provincetown is one of the most used by staging roseate terns on Cape Cod.

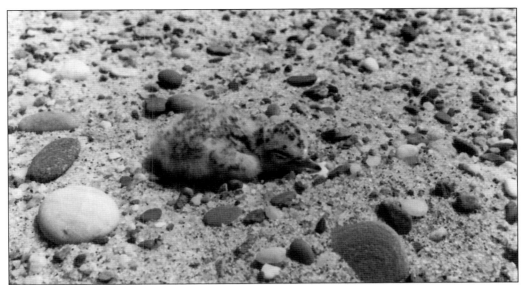

The least tern, the common tern, and the Arctic tern are listed as species of special concern in Massachusetts. The Arctic tern has historically nested on seashore beaches, but is now disappearing from Massachusetts, the southern limit of its range. Least and Arctic terns typically nest along sandy beaches in a zone extending from the drift line back to the thinly vegetated foredune. Their nests, pictured above, are sparse and difficult to see.

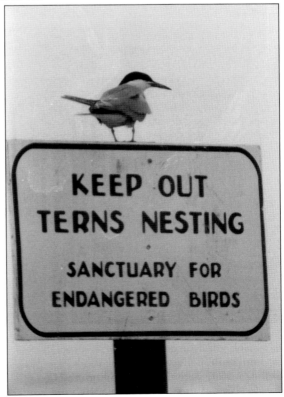

As early as mid-March, courtship, mate selection, and nest site selection occur, and eggs may be present on the beach. Egg and chick coloring make them highly camouflaged, and visitors to the beach often do not realize nests are there, despite repeated attacks by adult birds. Chicks sometimes respond to vehicles and/or pedestrians by crouching and remaining motionless. The seashore's proactive shorebird management plays a significant role in the recovery of these species.

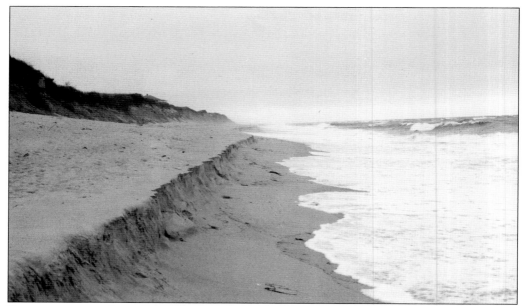

Erosion is a natural process on Cape Cod. The wide sandy beaches are made of sand that falls down from the glacial cliffs. Waves, currents, and wind then move much of this sand to other parts of Cape Cod, as seen by this erosion of the Outer Beach. The Province Lands, Nauset Spit, and the southern tip of Great Island were created by the movement of sand. If erosion of the beach cliffs was somehow stopped, these formations would disappear.

Beach grass planting is often used to help correct unnatural erosion when people or animals have trampled the grass. Beach grass traps the sand blown by the wind and is actually responsible for forming all of the dunes on Outer Cape Cod. Before the Pilgrims arrived, the beach grass in the Province Lands did such a good job of holding the dunes together that a complete forest existed there.

Human features such as buildings and parking lots often suffer severely from coastal erosion (the erosion rate of CCNS is approximately 5 acres per year). In 1977, the Old Harbor Life Saving Station had to be moved from North Beach in Chatham to its present location in Provincetown in order to save it.

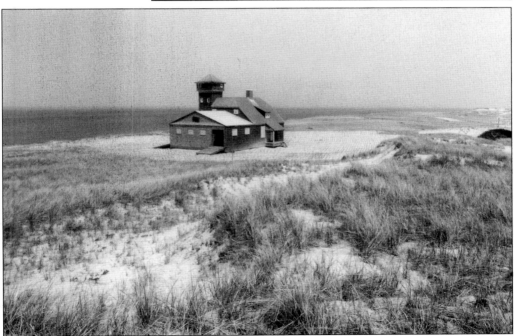

Old Harbor Life Saving Station was built in Chatham in 1897. The station was operated by the U.S. Coast Guard (and its precursor the U.S. Life Saving Service) until it was decommissioned in July 1944. It is seen here in 1977 after its move from Chatham.

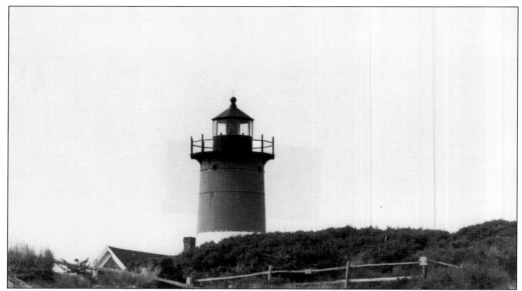

Nauset Light was built in Chatham in 1877 as a twin to the lighthouse that is still there. It was moved to Eastham in 1923 to replace "The Three Sisters," three movable wooden lighthouses. In the 1940s, Nauset Light was painted red and white to distinguish it from Highland and Chatham lights. Coastal erosion plagued the lighthouse, seen here in 1991. By 1996, it was less than 25 feet from the edge of the cliff.

The Nauset Light Preservation Society was formed in Eastham to rescue the lighthouse. In November 1996, it was moved to a new site about 300 feet west. As of April 1998, the keeper's house stood a mere 27 feet from the eroding cliff. In October/November 1998, the house was also moved. It was donated to the National Park Service, and the donor was allowed to continue to use it.

The Three Sisters lighthouses had been built of brick 150 feet apart on the cliffs in 1838. The original brick towers fell victim to erosion and in 1892 were replaced with three movable wooden towers. These were built further back from the cliff, but by 1911 the cliff had eroded to within 8 yards of the north tower. After being replaced by Nauset Light in 1923, the Three Sisters were sold to become parts of summer cottages. CCSN acquired all three and in 1990 moved them to a site off Cable Road in Eastham, where they are open to the public. Meanwhile, as seen in these photographs by Jim Owens, the foundations of one of the Three Sisters slid down the cliff.

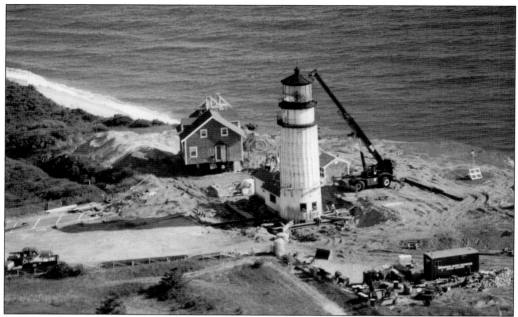

When the first Highland Lighthouse was built in Truro in 1797, it was over 500 feet from the edge of the 125-foot cliff. The cliff continued to erode at a rate of at least 3 feet a year until, by the early 1990s, the lighthouse stood just over a hundred feet from the edge. In 1990 alone, 40 feet of land was lost just north of the lighthouse. (Photograph by Steve Heaslip, *Cape Cod Times*.)

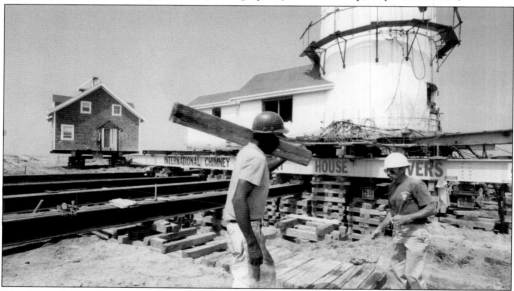

The Truro Historical Society helped raise funds for the move of Highland Light. This money was combined with $1 million in federal funds and $500,000 in state funds to move the 404-ton lighthouse to a site 450 feet away. The operation began in June 1996, under the direction of International Chimney Corporation of Buffalo, with subcontractor Expert House Moving of Maryland. Thousands of sightseers gathered to catch a glimpse of the rare move. (Photograph by Steve Heaslip, *Cape Cod Times*.)

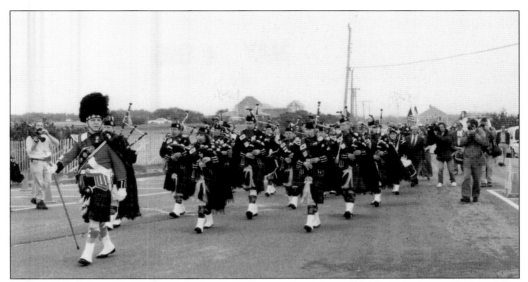

In November 3, 1996, Highland Light was relit in its new location. Over 200 people toured the tower's interior. The Highland Light Scottish Pipe Band performed in full regalia, and Congressman Gerry Studds, an important proponent of the move, spoke to the assembled crowd. "While this light may not save lives," said Studds, "it will inspire lives for a long time to come."

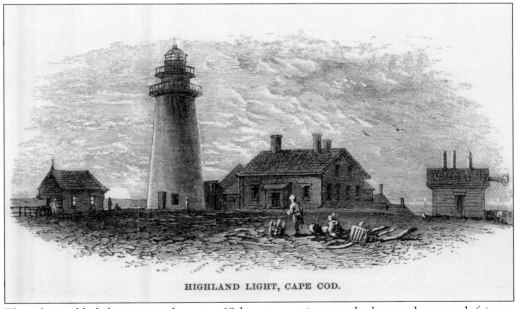

HIGHLAND LIGHT, CAPE COD.

The relocated lighthouse, seen here in a 19th-century print, stands close to the seventh fairway of the Highland Golf Links. This prompted some to declare the links the world's first life-sized miniature golf course. "We'll get a windmill from Eastham and put it on number one," joked the club's greenskeeper. After an errant golf ball broke a pane in the lantern room, new unbreakable panes were installed.

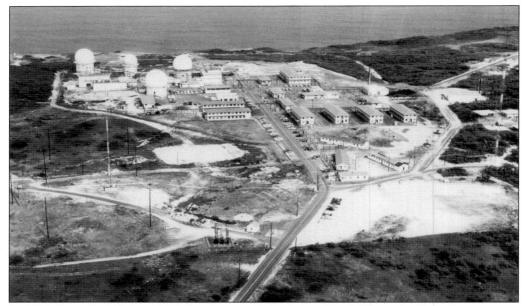

In 1994, Cape Cod National Seashore acquired the former North Truro Air Force Station, seen here in a 1958 photograph. From 1951 to 1985, radar scanned the skies searching for Soviet bombers moving across the Arctic Circle. CCNS has since made $1 million in improvements. A portion of the land was transferred to the Federal Aviation Administration, which uses radar to track international flights into Boston's Logan Airport and New York's Kennedy Airport.

The air force continues to use radar at the location to identify and track civilian and military aircraft. The site, now called Highlands Center, houses a community of artists, scientists, and educators, including Barnstable County's AmeriCorps, the National Park Service Atlantic Research Center, the Fine Arts Work Center, the Truro Center for the Arts at Castle Hill, and the Payomet Performing Arts Center.

One unanticipated controversy at the CCNS was summarized in the May 1990 *Law Review*: "In 1972 Brush Hollow attracted as many as 150 nude bathers in a day . . . The site of this controversy is . . . a 3-mile expanse between two conventionally operated beaches. For some 40 or 50 years this spot, hidden behind some of the highest dunes on the Cape, had been used by individuals, couples, and small groups for skinny dipping. The existence of the only 'free beach' on the east coast became . . . national news . . . In the summer of 1974 the average count of nude bathers was over 300, on weekends rising to 600, and attaining a peak of over 1,200 on one day in August. The Park Service, after considering other alternatives, including the allowance of nude bathing at other beaches . . . adopted the regulation . . . which bars public nude bathing within the seashore to all persons over ten years of age."

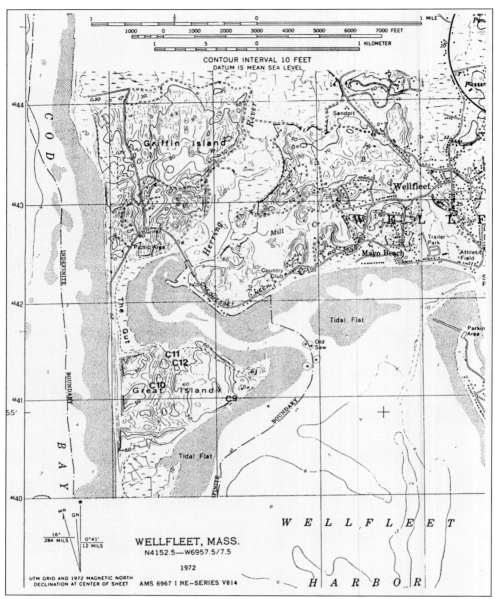

The national seashore's zoning regulations of 1962 called for zoning in towns within the seashore district to be "consistent with the objectives and purposes of the Act of Aug. 7, 1961, so that . . . the scenic, scientific and cultural values of the area will be protected, undeveloped areas will be preserved in a natural condition, and the distinctive Cape Cod character of existing residential structures will be maintained." On a tiny spit of land at the south end of Griffin Island in Wellfleet (above), a 550-square-foot cottage was knocked down in 1984 to build a 1,812-square-foot home. A family had this property taken down with the intention of building a 5,848-square-foot mansion, a 203-percent increase over the 1984 home and 963 percent over the original cottage. The Wellfleet selectmen weighed in on the issue, claiming the proposed home violated a part of current town zoning bylaws that only allows uses that "are not incompatible with the character of the park, including the preservation of natural and scenic areas."

112

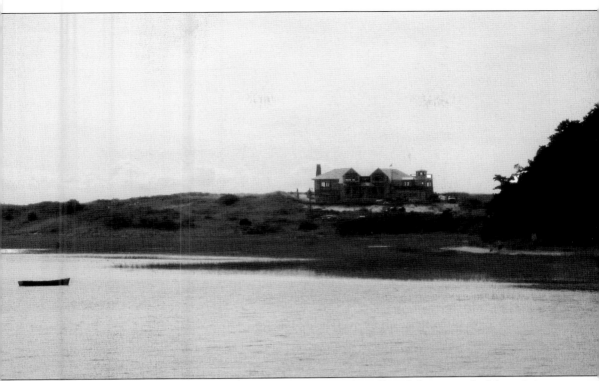

The Wellfleet building inspector issued the building permit that allowed the removal of the existing 1,812-square foot home on Chequessett Neck Road and the replacement of it with a 5,848-square foot home. The Wellfleet zoning bylaws had never been reconciled with the national seashore guidelines, thus the dimensions of new home were indeed within the square footage requirements of the Wellfleet bylaws. The Wellfleet zoning board of appeals upheld the building permit. The U.S. Department of the Interior issued a motion for a temporary injunction to stop construction of the controversial house, seen above, but a Massachusetts land court judge denied the motion. The judge warned the family that continued construction on the house would be done "at their own peril pending the outcome of this litigation." Meanwhile, Wellfleet had proposed and passed new zoning bylaws, of which CCNS superintendent George E. Price Jr. said, "They represent the best reflection of needed changes to address building scale and mass and retain community character as envisioned in the park legislation and the federal zoning standards regulation for the national seashore."

One of Cape Cod National Seashore's greatest challenges—the high volume of automobile traffic—led to one of the seashore's greatest successes. In 2006, Supt. George E. Price Jr. announced that, "Starting this summer, twelve new passenger buses connect communities from Harwich to Provincetown and the national seashore. The new FLEX system will operate on a 30-minute, pick-up summer schedule, and 60-minute winter schedule. Special pick-ups, up to 3/4 of a mile from the set route, can be arranged."

Roy Jones, Brewster fire chief, chaired the FLEX planning committee with representatives from seven towns and the seashore. Eastham resident Mary Lou Pettit said, "This has been a dream of mine for 20 years." This photograph shows chief of maintenance Ben Pearson having his FLEX (for "flexible") bus fueled. Former Provincetown town manager Keith Bergman called this program "the most successful joint project undertaken thus far by the Cape communities and the National Park Service."

Ten

THE NEXT 50 YEARS

George Price Jr., superintendent of CCNS since 2005, has said, "People often tell me I have the best job in the world! I have to agree with them. Working for the National Park Service has been an amazing experience. Our national parks have been called 'America's best idea.'" Price looks ahead to a future of regional and national collaboration to protect both the natural wonders and the special cultural features of CCNS.

The next 50 years of CCNS will be exhilarating and demanding. There are large-scale restoration projects, like the restoration of the Herring River estuary, seen here. There are plans to furnish the Old Harbor Life Saving Station, for new exhibits, and the "greening" of national seashore operations. Overdevelopment will continue to be a challenge. "My number one concern is this issue of large houses. It could have a dramatic, cumulative effect," says Superintendent Price.

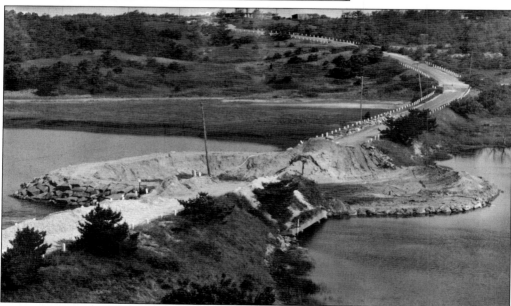

The Herring River estuary has been seriously compromised since 1908 when the 1,200-acre salt marsh was reduced to 7 acres by a dike. During the past 100 years, upland vegetation invaded the flood plain, lack of flushing contributed to low levels of oxygen, and acidic conditions supported mosquitoes and high levels of bacteria. Fish kills and routine closures of adjacent shellfish beds eventually received attention.

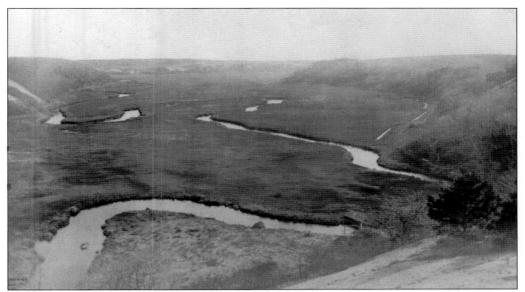

The Herring River Restoration Project is the largest and perhaps most ecologically complex estuary restoration in the northeast. So far, over 17 private, local, state, and federal partners have been involved. Social concerns remain, however, including sediment transport to downstream shellfish aquaculture grants, insect production, the flooding of low-lying roads, and the private wells and grounds within the coastal flood plain. The aerial photograph shows the area before the dike was built.

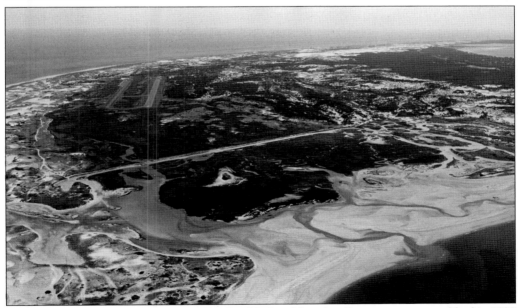

Similar to the Herring River estuary, Hatches Harbor (above) in Provincetown was diked in 1930 in an unsuccessful attempt to eliminate mosquitoes. The Provincetown airport was built on the floodplain shortly thereafter. In 1998, saltwater flow was restored, and since then shellfish have recolonized and estuary fish are again foraging in tidal creeks. The project has also provided the airport with additional protection from storm surges.

East Harbor, formerly known as Pilgrim Lake, offers a serene welcome when Provincetown is approached by land. It, along with Moon Pond and Salt Meadow, is part of 720-acre East Harbor. All of this has been artificially isolated from the sea since 1868, when the original inlet was filled. Oxygen depletion and a fish kill involving about 40,000 alewives in September 2001 were alarming. Officials from Truro, Cape Cod National Seashore, and the state consulted on possible measures to improve water quality. Between 2004 and 2005, with the opening of the existing culvert to tidal flow, water clarity in East Harbor improved dramatically. What was once a very turbid area with almost no visibility now has a sandy bottom that can be seen through clear water across the entire lagoon. East Harbor has reverted to a rich saltwater habitat with sticklebacks, silversides, mummichogs, pipefish, winter flounder, blue mussels, hard clams, soft-shelled clams, oysters, shrimp, horseshoe crabs, sea anemones, and sea squirts. Despite the significant gains in species diversity, water quality, and overall ecological health of East Harbor, impairments still remain. More complete restoration could expand salt marsh plant communities.

Heathlands have been part of the Cape Cod landscape since the last ice age. The most extensive coastal heathlands in the United States today occur within Cape Cod National Seashore and the islands. They contain a diversity of species not found anywhere else in southern New England. Up to 500–700 acres of heathland around the Marconi area (above) and acreage on Fort Hill will be restored, bringing back much lost habitat.

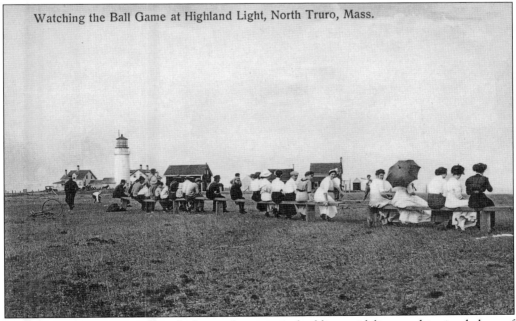

Watching the Ball Game at Highland Light, North Truro, Mass.

CCNS continues to struggle with the gap between its building guidelines and zoning bylaws of individual towns. Truro's zoning has yet to be reconciled with the seashore guidelines. Thus, a permit was recently issued for the demolition and "reconstruction" of a Truro house within CCNS boundaries. The new house is three-and-a-half times larger than the original 700-square foot house. This postcard shows a simpler era in Truro.

In March 2009, some $1.75 million in federal money completed funding to preserve the North of Highlands Campground in Truro. Congressman Bill Delahunt and Sen. Ted Kennedy had acquired the first $2 million in 2006. Surrounded by national seashore lands, the 57-acre property includes 20 acres of undisturbed woodland and wetland and the 37-acre wooded campground. Protection will allow future generations to enjoy rustic camping within CCNS. Pictured above are Congressman Bill Delahunt, Sen. Ted Kennedy, and owners Evelyn and Stephen Currier at the announcement of the first funds to preserve North of Highlands Campground in October 2006. In the photograph below are Supt. George Price in uniform and Senator Kennedy, seated. No sooner had one Truro campground been saved from development, when another one was put up for sale.

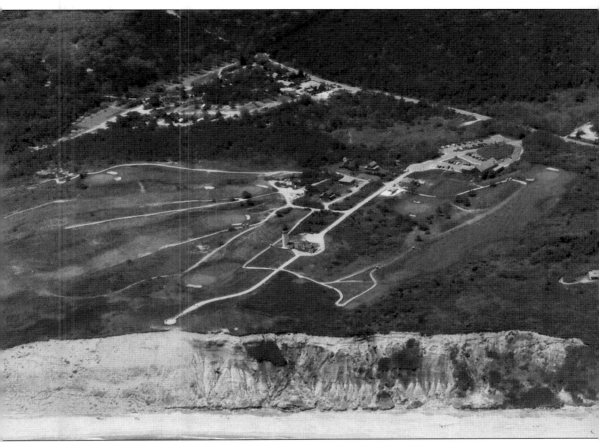

On November 12, 2009, the *Provincetown Banner* announced what will be a major new development challenge within the national seashore: "Trees, grassland and empty hills make up the campground that has operated for more than 50 years next to historic Highland Light in North Truro. But will subdivisions and 'trophy' homes crop up there in the future? Horton's Camping Resort, at 71 South Highland Road, is on the market, raising concern on the part of at least one abutter, the national seashore, that it could be targeted for development. The 39-acre property lies within park boundaries, bordered on one side by Highland Light, the Highland House Museum and Highland Links—all owned by the seashore—and on the other by the seashore's Highlands Center." Supt. George Price Jr. said, "We've seen a number of campgrounds, low-end cottages, or motels go by the wayside. So maintaining an opportunity for camping out on the Cape is going to be critical." This aerial photograph shows the entire area, with Highland Light at center and Horton Campground at top left.

Park historian Bill Burke emphasizes to the need to preserve the Cape's recent cultural past: "Since World War II, modern architects like Breuer, Chermayeff, and Hammarstrom had been quietly inserting into the scented pine forests of Wellfleet architectural gems." One of them, the Hatch House (shown above with Ruth Hatch in 2003), was designed by John Hughes Hall.

Several remarkable homes were designed for the ponds in Wellfleet. Bill Burke has written, "There are over 50 significant modern houses from this lineage on the Outer Cape, and the seashore and local preservation groups are spearheading an effort to preserve some of them . . . The 1953 Weidlinger House [above] was designed by Paul Weidlinger on Higgins Pond. It illustrates an all-embracing attitude toward modern design, taking into account the topography and environment and treading lightly on the land."

Park historian Bill Burke remarks, "A strong continuum between the past and the present makes the past seem more relevant to our own lives. [It] is as much about what's saved as it is about how we value the built environment in our own backyards." The Kuhn House was built in Wellfleet in 1960. Designers Nathaniel Saltonstall and Peter Morton were colleagues of Breuer and Gropius.

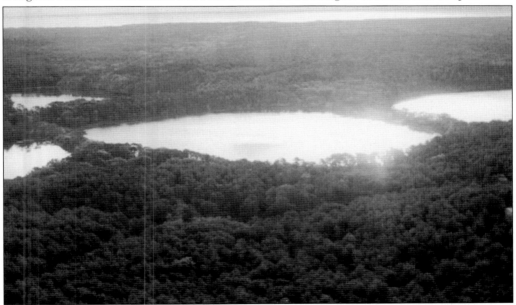

This view of Great Pond, Wellfleet, recalls the words of Supt. George Price's *Centennial Strategy* report of 2007: "Cape Cod is . . . a place to enjoy the beauties of land, sea, and sky, to marvel at the power of a storm-driven ocean, and to reenergize the human spirit. Cape Cod National Seashore was set aside in 1961 to help preserve the special qualities that give this slender peninsula in the Atlantic Ocean its unique place in the American psyche."

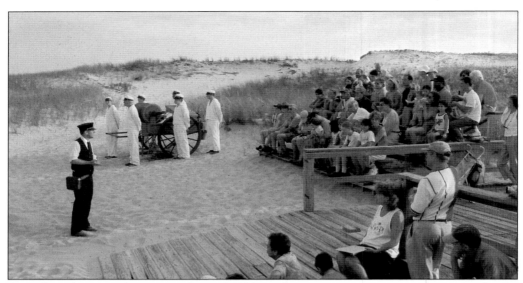

An informal survey of present and past CCNS employees turns up a variety of concerns for the next 50 years: Mike Whately, and John Portnoy consider global warming and the rising sea level critical. Jack Farley and David Spang emphasize the need for zoning and the preservation of open space. Bill Burke sees the need for more satellite parking and shuttles, for the restoration of large ecosystems like Herring River, for the care of historic structures, the need to make CCNS ecologically sustainable, and to keep it affordable for all to visit. Both Jenna Sammartino and David Spang look to new, interactive ways to engage the public. This means keeping popular demonstrations of historical lifesaving apparatus and adding programs like Jenna Sammartino's innovative beach yoga class.

These words of Henry David Thoreau are every bit as true now as they were when he wrote them in 1865: "Thus Cape Cod is anchored to the heavens, as it were, by a myriad little cables of beach-grass, and, if they should fail, would become a total wreck, and erelong go to the bottom . . . We often love to think now of the life of men on beaches—at least in midsummer, when the weather is serene; their sunny lives on the sand, amid the beach-grass and the bayberries . . . their wealth a jag of driftwood or a few beach-plums, and their music the surf and the peep of the beach-bird."

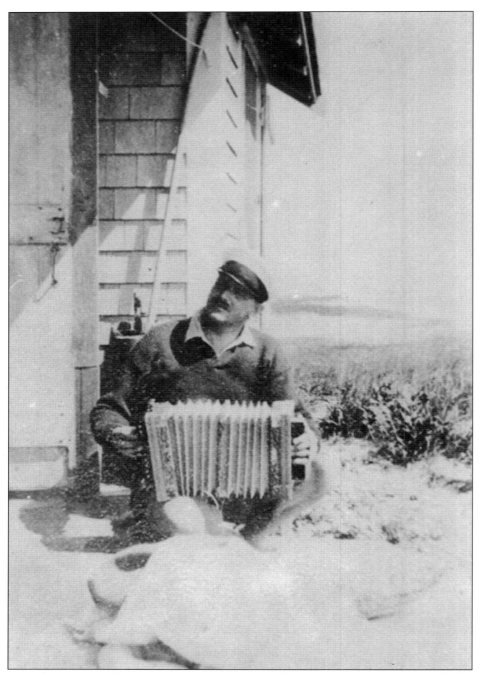

This rare photograph of Henry Beston playing his accordion in the snow contrasts with his deeply felt words: "A human life, so often likened to a spectacle upon a stage, is more justly a ritual. The ancient values of dignity, beauty and poetry which sustain it are of Nature's inspiration; they are born of the mystery and beauty of the world. Do no dishonor to the earth lest you dishonor the spirit of man. Hold your hands out over the earth as over a flame. To all who love her . . . she gives of her strength, sustaining them with her own measureless tremor of dark life."

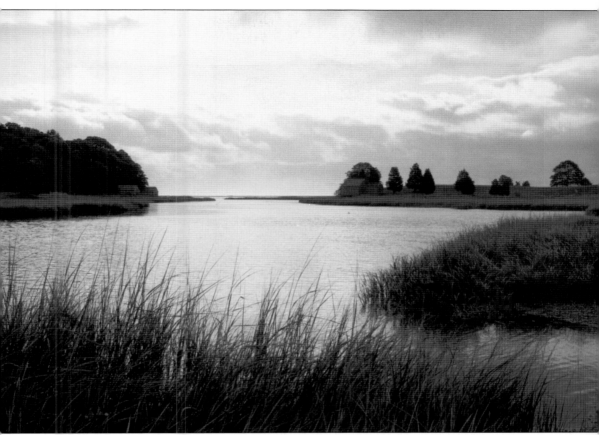

Looking across Salt Pond in Eastham, to Nauset Marsh, one can see beyond to the Atlantic Ocean, where Henry Beston had his Outermost House. There he wrote the following: "Touch the earth, love the earth, honor the earth, her plains, her valleys, her hills and her seas; rest your spirit in her solitary places. For the gifts of life are the earth's and they are given to all, and they are the songs of birds at daybreak, Orion and the Bear, and dawn seen over ocean from the beach."

www.arcadiapublishing.com

MAP SEARCH

Discover books about the town where you grew up, the cities where your friends and families live, the town where your parents met, or even that retirement spot you've been dreaming about. Our Web site provides history lovers with exclusive deals, advanced notification about new titles, e-mail alerts of author events, and much more.

MADE IN THE USA

Arcadia Publishing, the leading local history publisher in the United States, is committed to making history accessible and meaningful through publishing books that celebrate and preserve the heritage of America's people and places. Consistent with our mission to preserve history on a local level, this book was printed in South Carolina on American-made paper and manufactured entirely in the United States.

This book carries the accredited Forest Stewardship Council (FSC) label and is printed on 100 percent FSC-certified paper. Products carrying the FSC label are independently certified to assure consumers that they come from forests that are managed to meet the social, economic, and ecological needs of present and future generations.

FSC
Mixed Sources
Product group from well-managed forests and other controlled sources

Cert no. SW-COC-001530
www.fsc.org
© 1996 Forest Stewardship Council

Find Your Place in History.